Gianni Versace

To the princess
of Wales, who has
glamourized royalty,

Rock and *Royalty*

and to my dear friend
Elton who has become
a "royal" of rock.

A TINY FOLIO™
Abbeville Press Publishers
New York London Paris

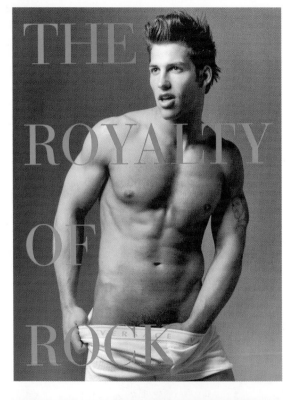

THE
ROYALTY
OF
ROCK

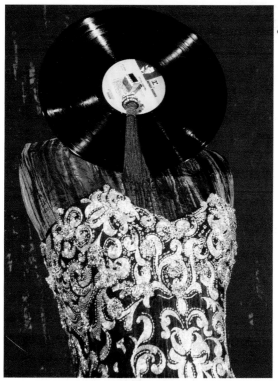

"I always have to dress for an audience. They expect it. It is an essential part of my performance."

Elton John

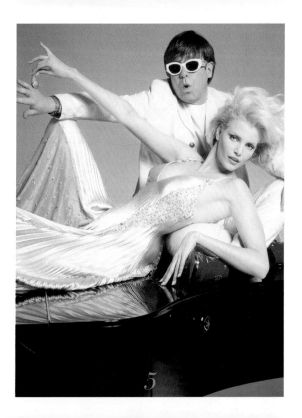

"Great performers have always had a sense of the dramatic and what they choose to wear enhances that sense. It adds another dimension to their act."

Elton John

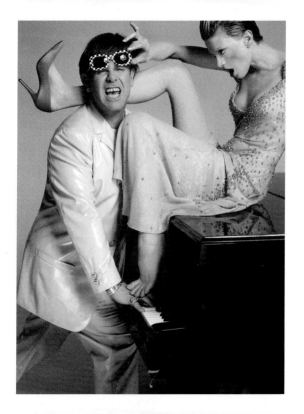

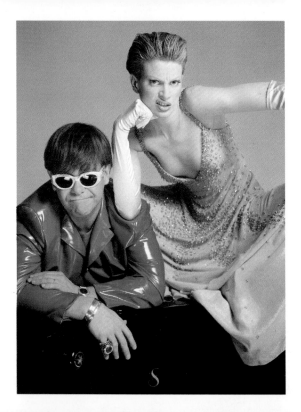

"Fashion is like art to me. The creative process of fashion never ceases to amaze or impress me."

Elton John

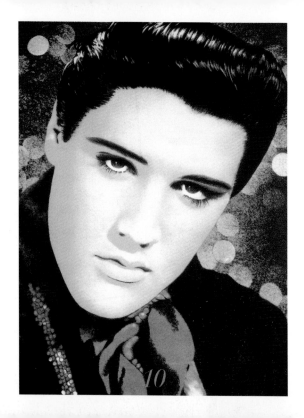

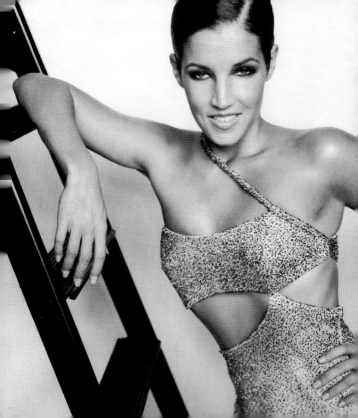

"The worlds of fashion and rock'n' roll influence each other greatly."

Jon Bon Jovi

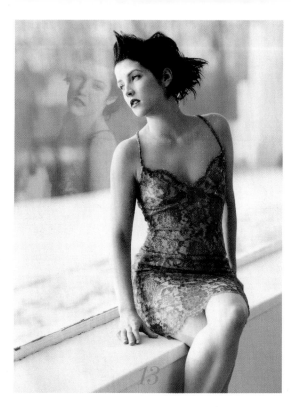

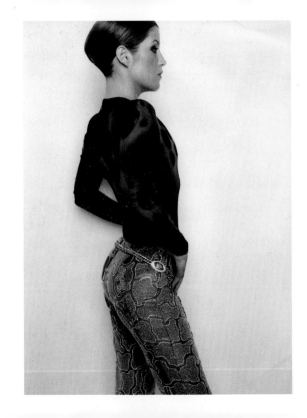

"Fashion and rock'n'roll are joined at the hip. It all started when Elvis dressed the youth of America and Beatles suits swept the world."

Jon Bon Jovi

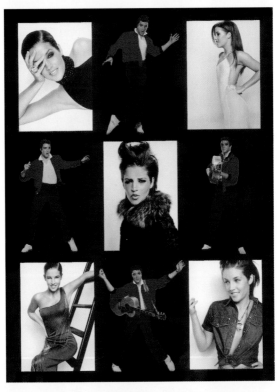

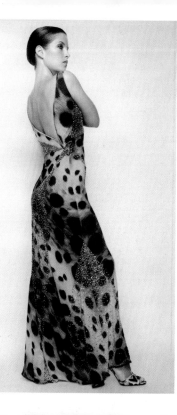

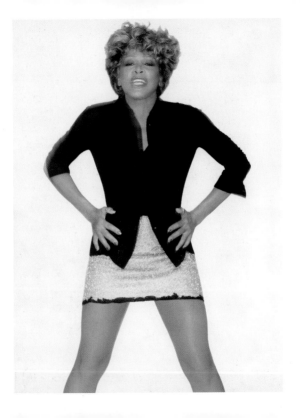

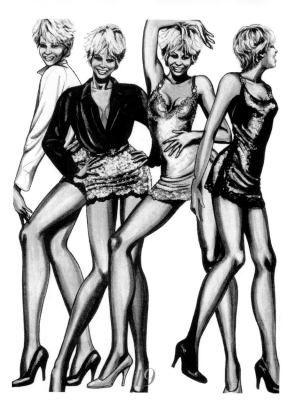

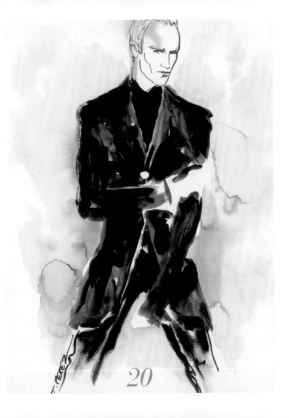

20

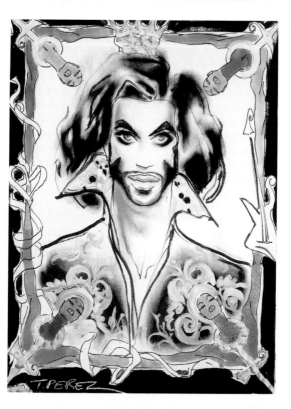

T.PEREZ

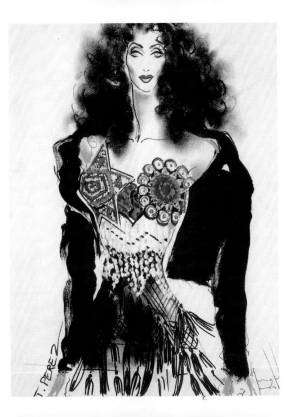

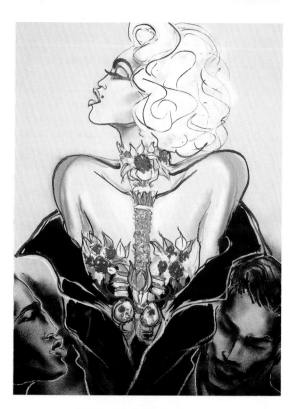

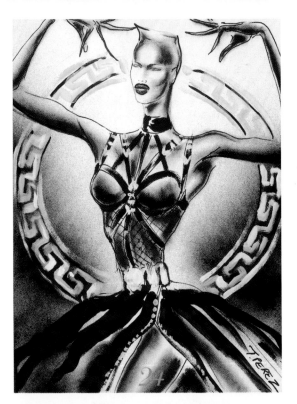

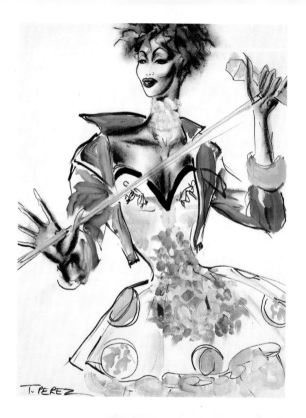

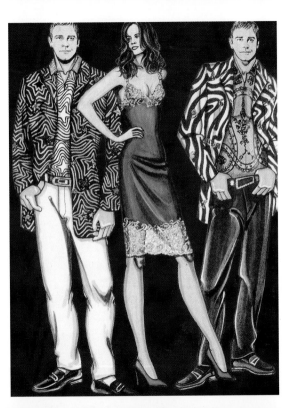

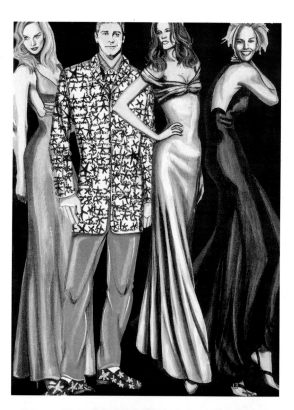

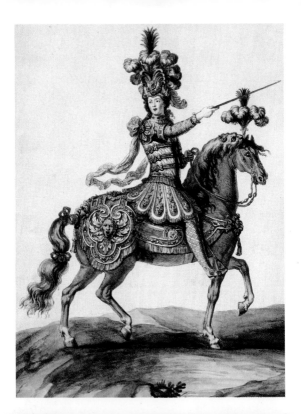

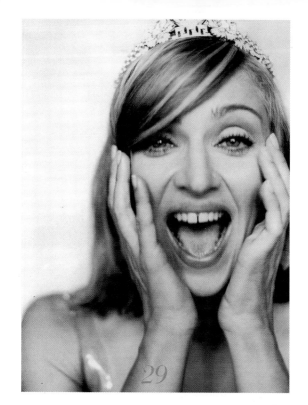
29

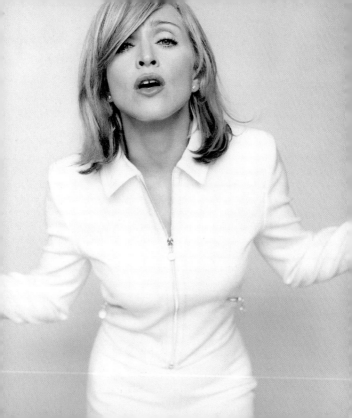

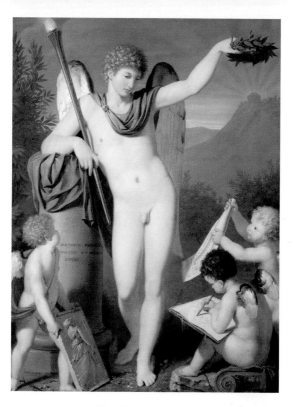

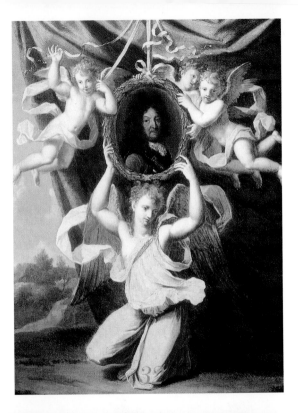

"Fashion becomes an ultimately important and tactile extension of a performer's personality taste."

k.d. lang

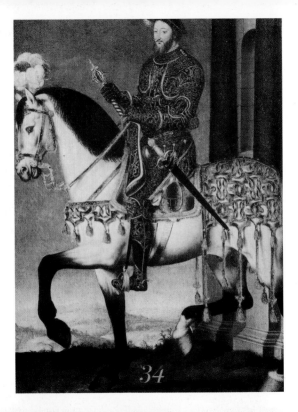

34

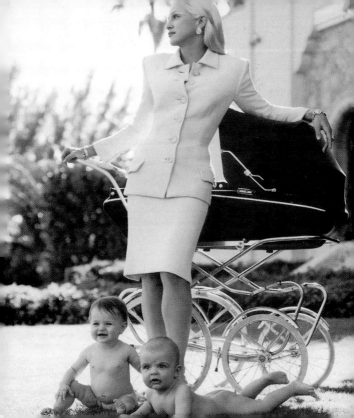

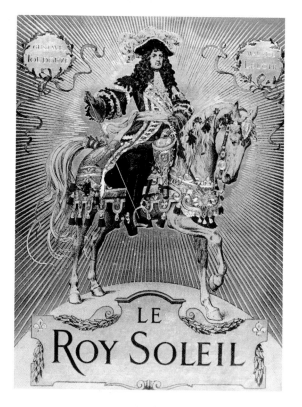

GUSTAVE TOUDOUZE

MAURICE LELOIR

LE
ROY SOLEIL

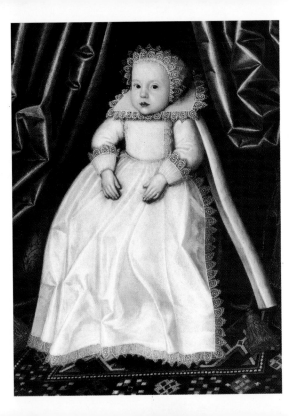

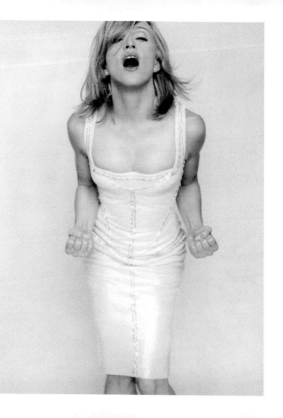

"As part of a performance, fashion must be thematically in sync with the vibe of the music."

k.d. lang

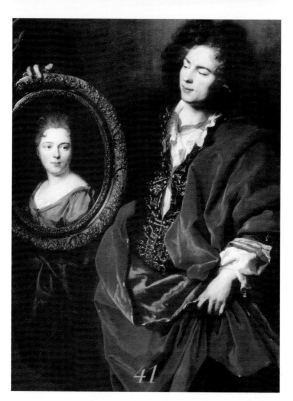

41

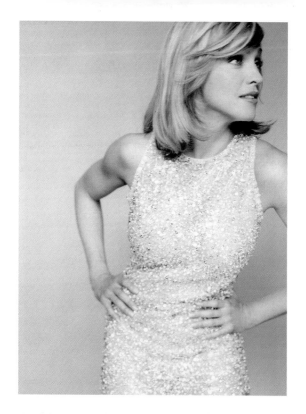

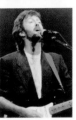
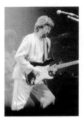
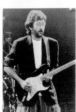
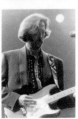

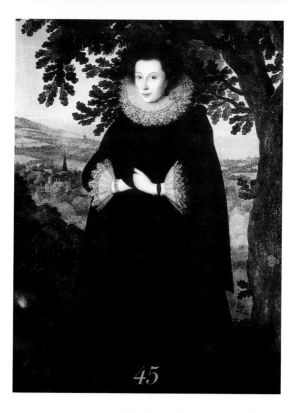

45

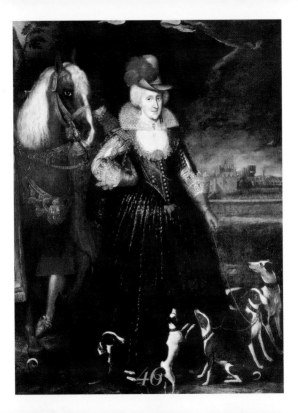

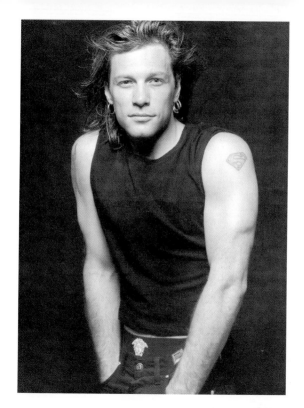

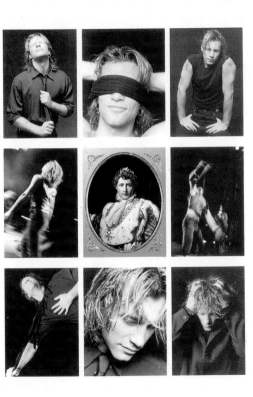

Wearing Versace fashion is like driving a Ferrari 70 mph with the top down and the radio blasting. They're both fast, loud and rip every curve

Jon Bon Jovi

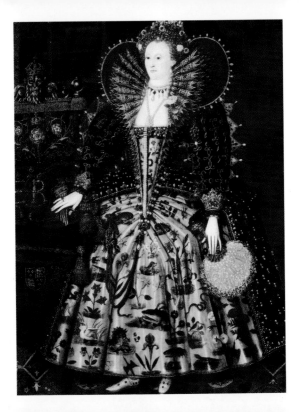

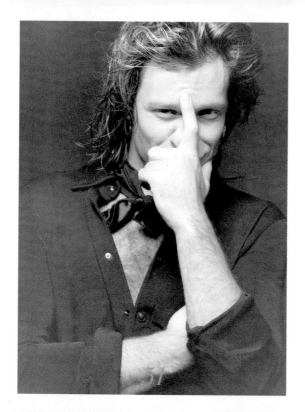

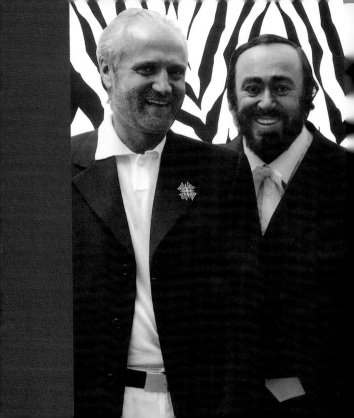

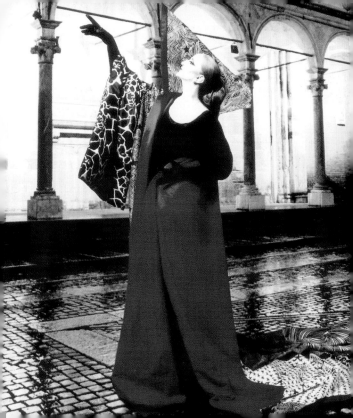

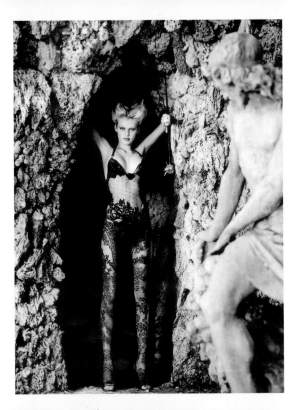

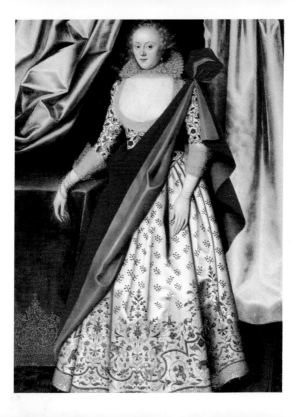

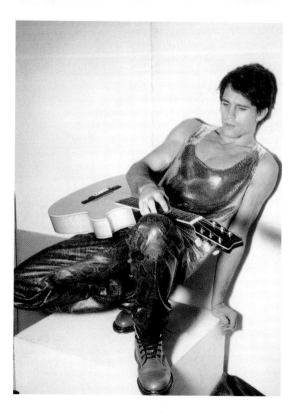

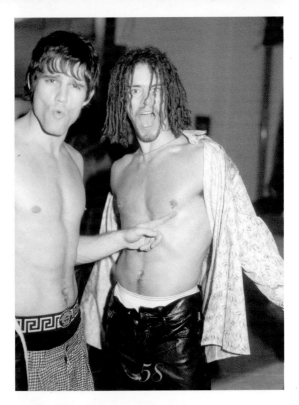

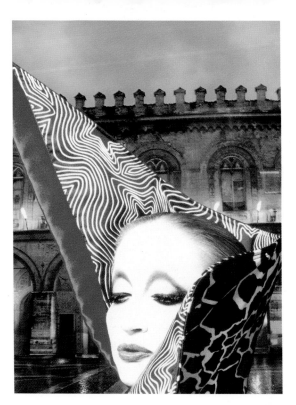

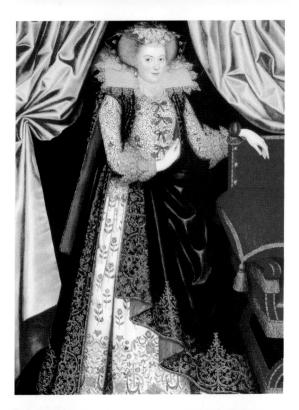

"Fashion and music are worlds of fantasy...that everyone can participate in."

k.d. lang

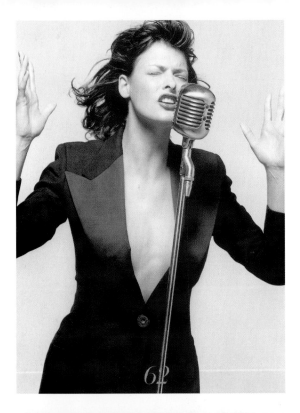

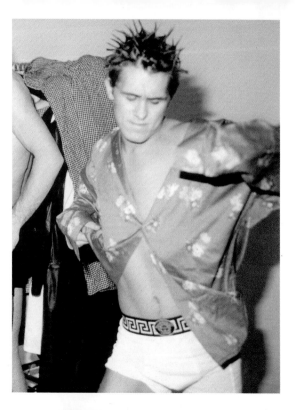

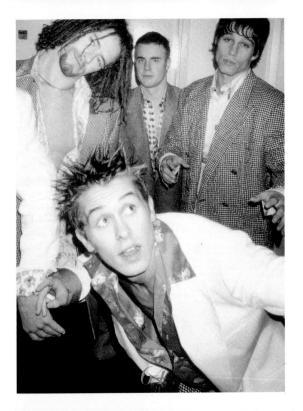

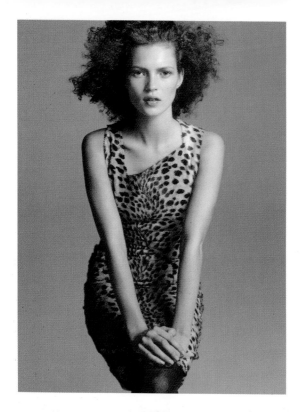

"Versace fashion is elaborate, colorful and strong. It's playfully classy and immediately rich."

k.d. lang

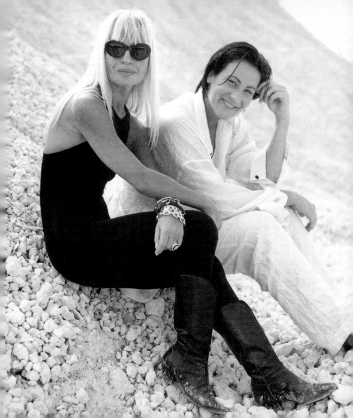

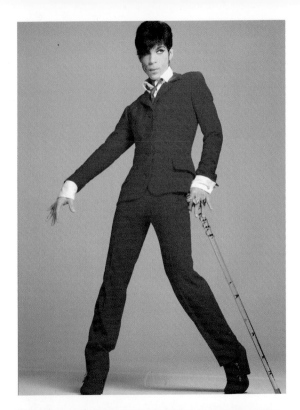

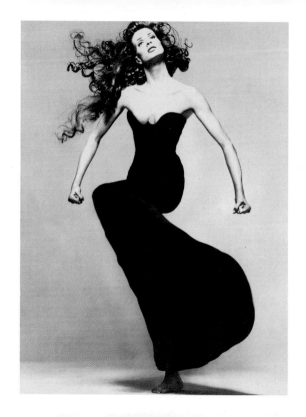

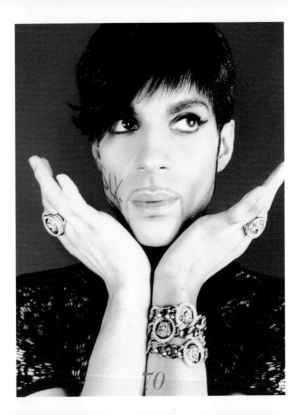

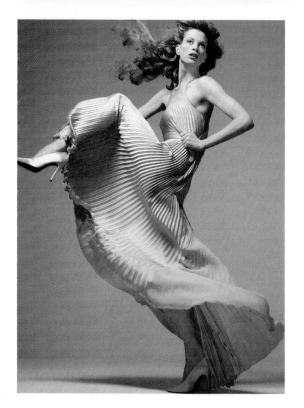

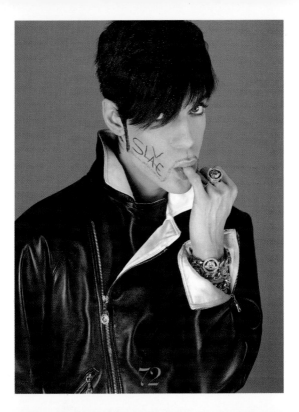

72

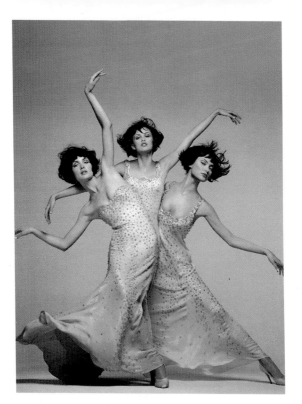

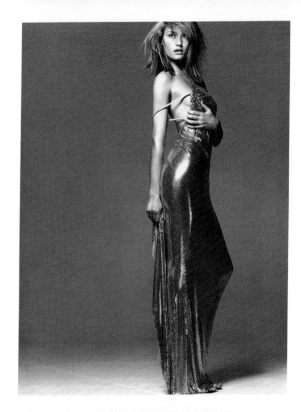

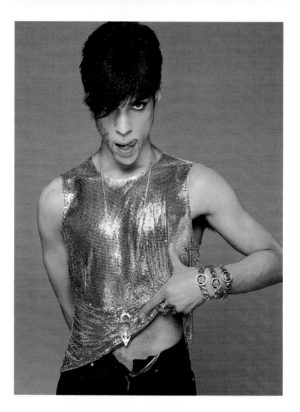

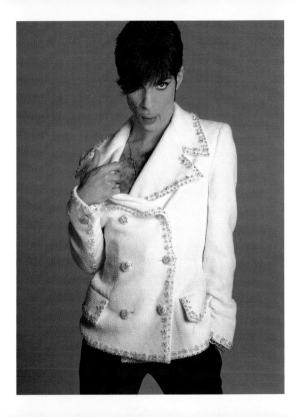

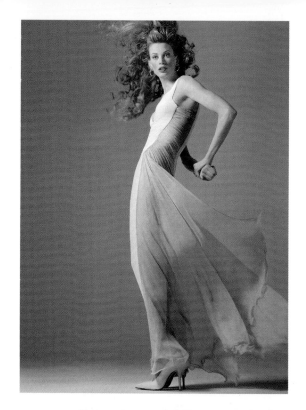

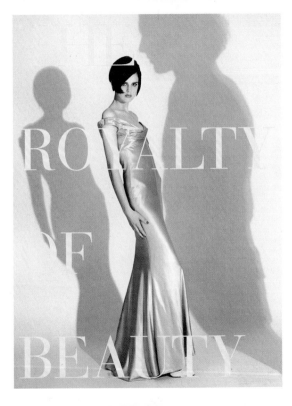

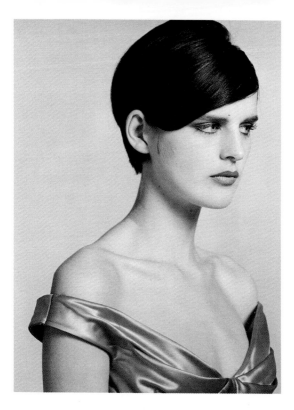

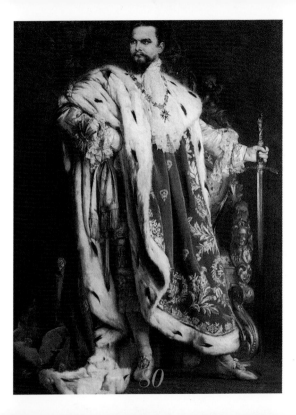

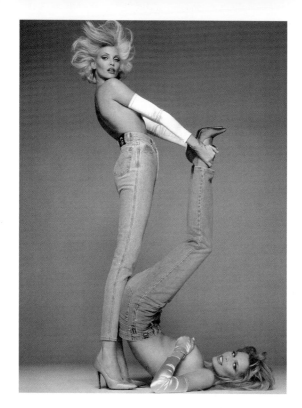

"Some people are born royal. Others become Queens on their own."

Elton John

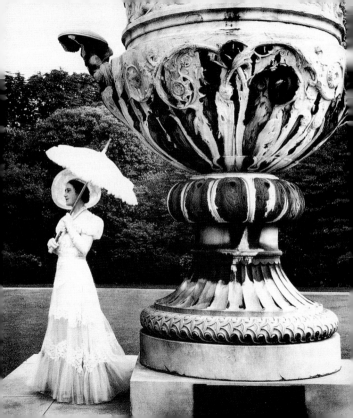

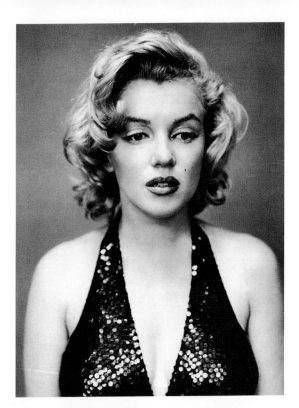

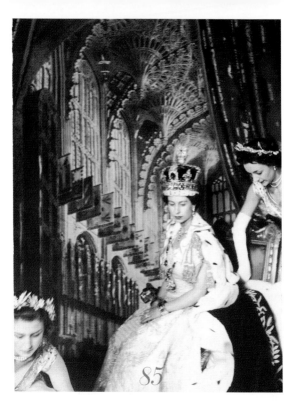

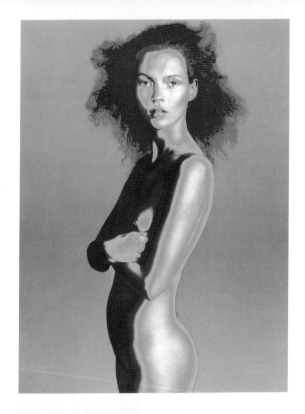

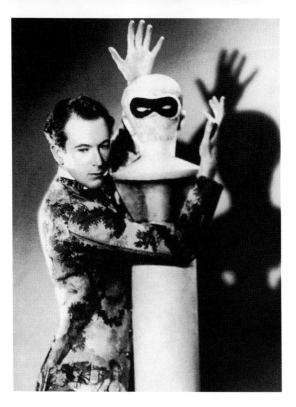

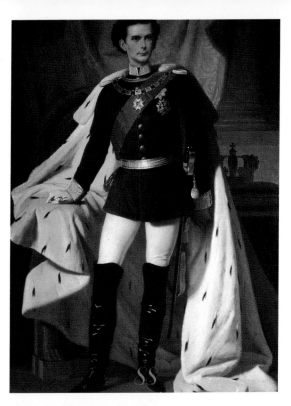

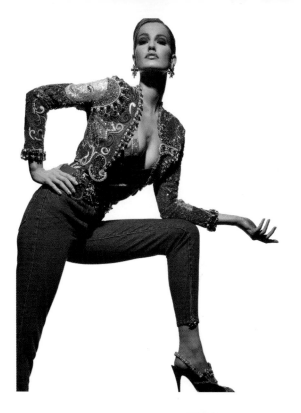

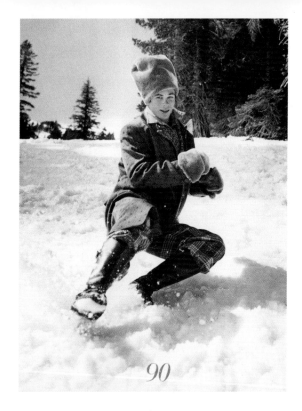

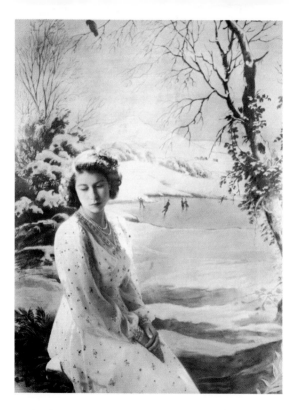

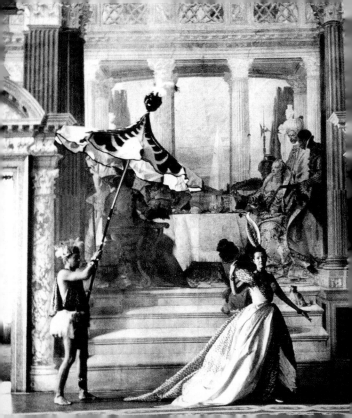

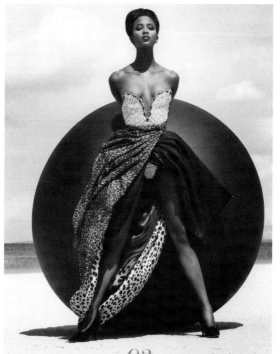

93

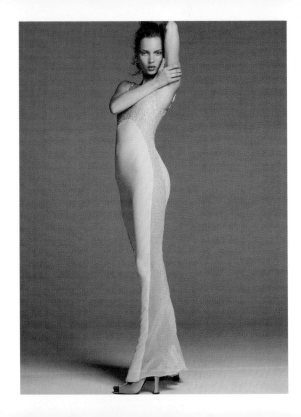

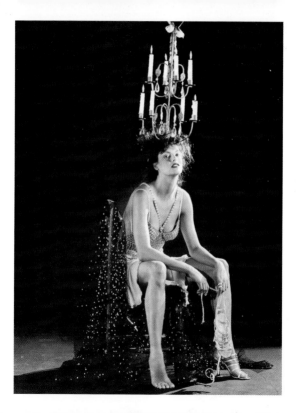

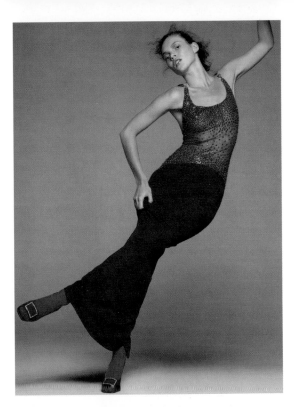

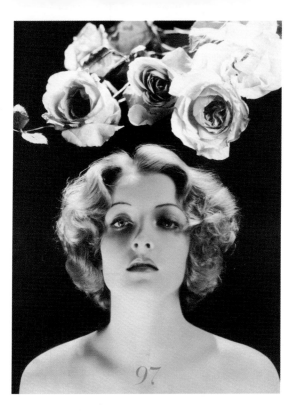

97

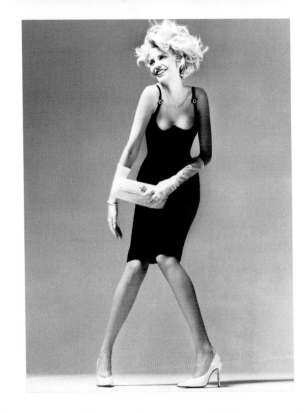

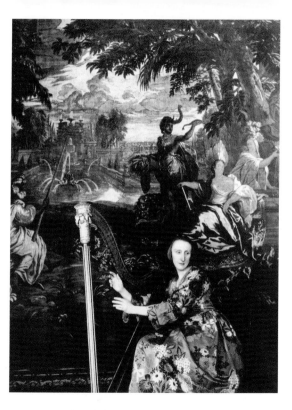

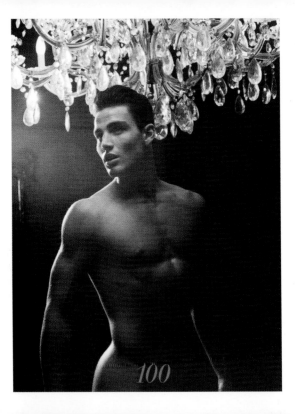

100

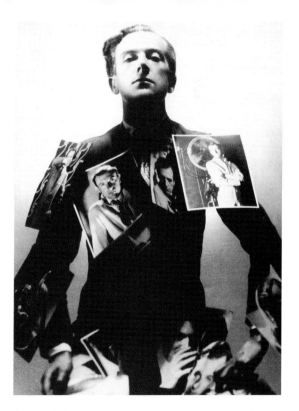

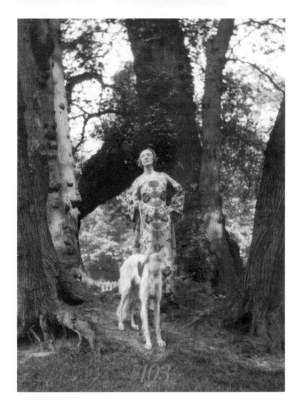

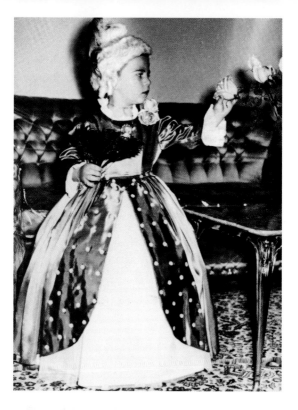

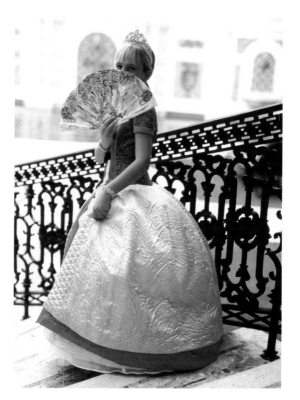

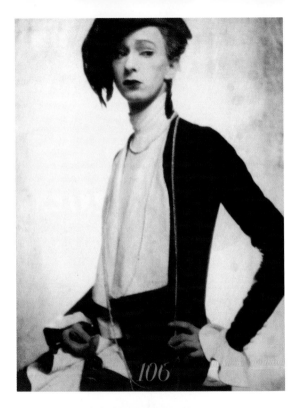

106

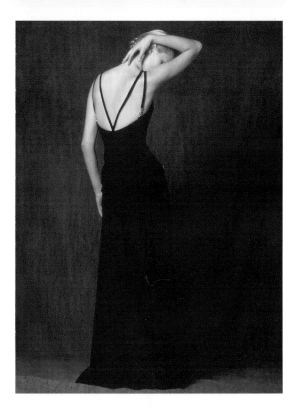

♦ Like many of us, when I grew up, royalty was still something that seemed like it came out of a book of fairy tales, and represented people whose lives seemed to never touch the ground. The images one got of royals was of people sitting on thrones—on horses, in carriages, or up in opera boxes, looking down at the crowds. The daily realities that made up ordinary people's existences didn't seem to be a part of what happened to kings and queens and their families. I remember the first time it registered with me that this might not be the case. I was about eleven, and living in a country which was very much involved with its royal family: Scotland. I had a friend whose claim to frame was that she knew somebody who in turn knew somebody who went to school with Princess Anne. One day my friend told me something that brought my concept of royalty down to earth. She explained that the princess didn't like all that waving that was expected of her when she went out in public. Apparently it was exhausting for her elbow, and she'd shown some of her schoolmates a waving technique she'd learned to keep her arm from being tired—she'd twist her hands as if she were opening a champagne bottle. Whether or not there was any truth to this story, I loved it—because it popped the myth that people who have the title of royalty don't have the kinds of troubles that everybody else has. Now we know just how true it is that kings and queens and princes and princesses are as human as the rest of us. ♦ But those were still the days when everybody expected bluebloods to act as if they were not made of flesh and blood. In Scotland I could see just how worked up the world could become over royalty. The great scandal of the time was still over the fact that the queen had come to Scotland and worn the same hat that she'd had on at a ceremony in England. To my friends all this fuss over pomp and circumstance was silly. It was 1963, and it was the new world not the old world that obsessed us. This new world was coming to us through the sounds that we were hearing on the radio, and on our record players. We had a routine that would never bore us. Every Saturday morning we'd get together; school uniforms off, jeans on; armed with our favorite singles and some bottles of pop. We'd lie on the floor, close our eyes, and listen to songs that would transport us. There was Cliff Richard and the Shadows, singing "We're all going on a summer holiday."

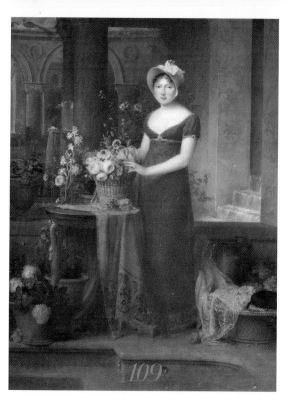

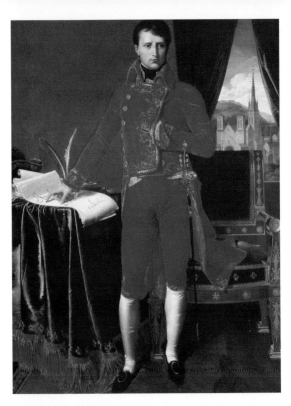

♦ In rainy Scotland, with the weight of our undone homework on our minds, this song to us was better than a ticket to the moon. And then, of course, there were the Beatles. Every time we'd put on "Twist and Shout" it would be goodbye to the week's demands of behaving properly like nice young ladies. We'd dance as we were never going to stop, and sing our lungs out. ♦ We kept up this Saturday morning routine for a few years. By 1965 we were at the age when boys had become a subject of some interest, but really there was only one band of boys who had our hearts—Herman's Hermits. Their song "I'm Henry the Eighth I Am" really did it for us. We could play it over and over and never tire of it. Needless to say when Herman's Hermits came to our sleepy town we stood watch at the hotel where they were staying, in the hopes of getting a glimpse of the band. We would never have done that for Henry the Eighth himself. Now I see that our affection for that tune represented something bigger than we realized then. It was a story about a common man who found his royalty inside himself. It was a song that captured the essence of what it is about pop music that has made it such a symbol of all the changes that have happened in the world. ♦ I don't know whether Gianni Versace has ever used this song in his collections, but I do know that he understands the empowerment of rock'n' roll. He suffuses his world with rock'n'roll. When you call the Versace headquarters there's rock'n'roll on the tape. When you go to a Versace show there's rock'n'roll to accompany the presentations of the clothes, and there are rock'n'rollers in the audience. There are also often rock'n'roll stars in his advertising. The presence of all this rock'n'roll matches what it is that Versace wants to do as a fashion designer. He wants to rock all the old boundaries that get in the way of people's freedom to rule their own lives. And he celebrates the fact that we have come to a point where we can do that more than we ever have before. His observation that rock'n'rollers are the new royalty is really a nod to each of us that a crown is not something you're born with, but something you earn. ♦ I wish he'd designed our school uniforms when I was a young girl in Scotland. For that matter, I bet the queen wouldn't mind an outfit or two by him. Some of her daughters-in-law are already customers. Even royalty wants to rock.

Ingrid Sischy

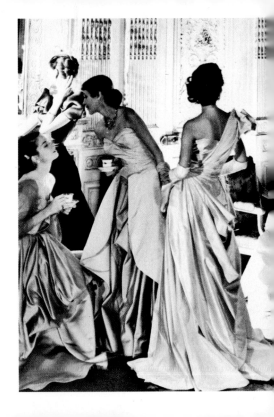

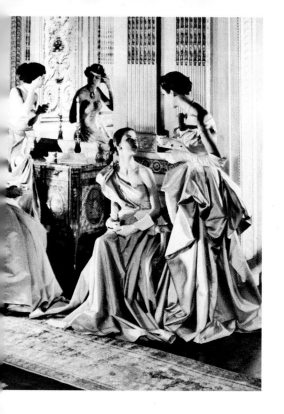

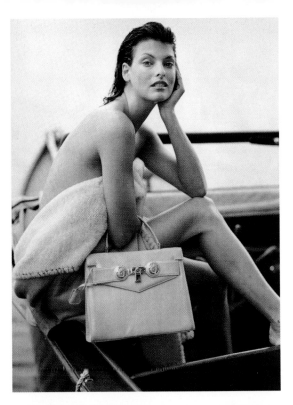

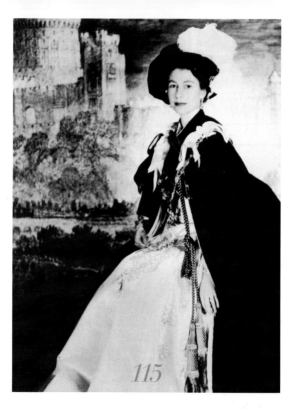

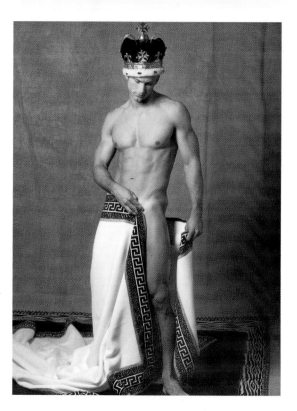

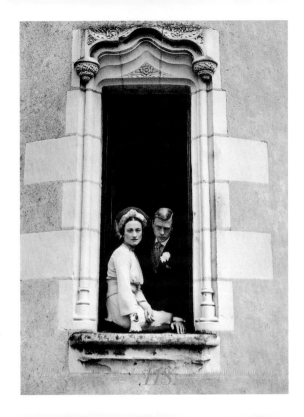

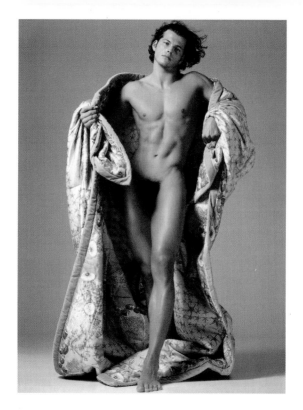

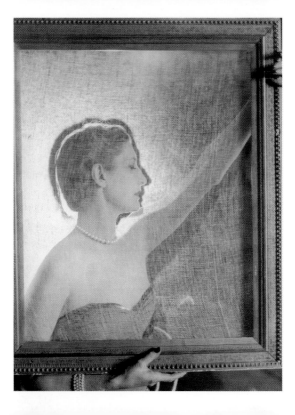

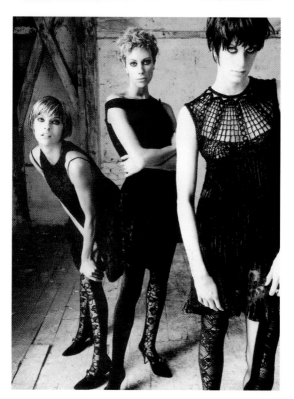

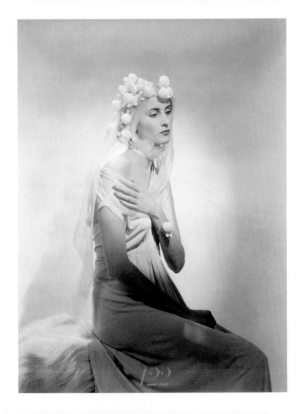

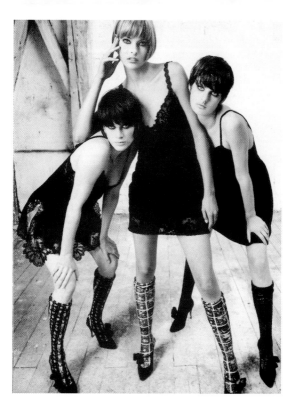

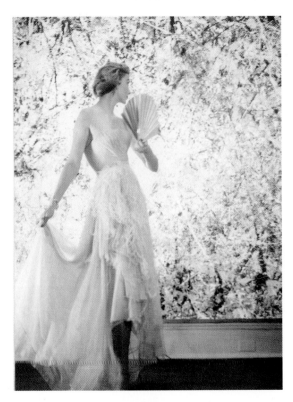

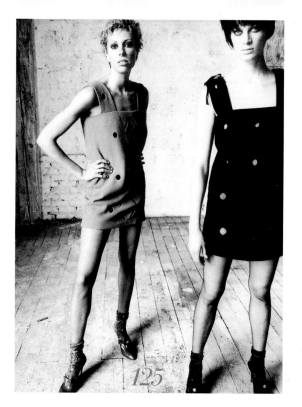

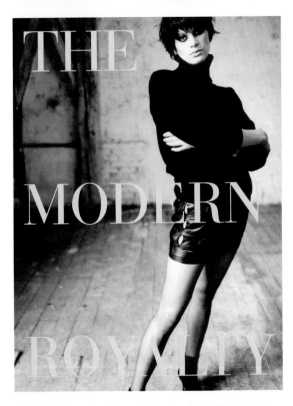

THE

MODERN

ROYALTY

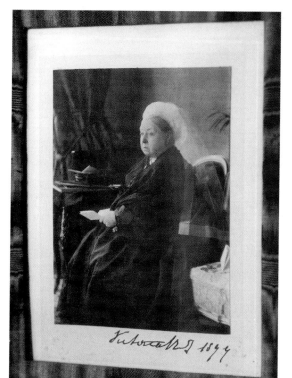

Victoria R J 1897

"Trudie and I are very proud

[...] our own [...] are [...]

fans of Golden Retrievers. No one [...]

and a love of life into the world [...]

is of vital importance. Not [...]

this terrible disease, but for

future generations. No one can

o be patron of The Elton John

... friends ... great

as done more to bring excitement

f fashion. Research into AIDS

nly for those suffering from

urselves, our children and for

fford to be complacent."

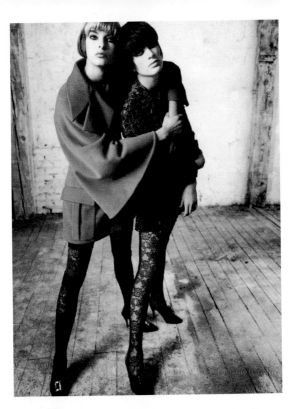

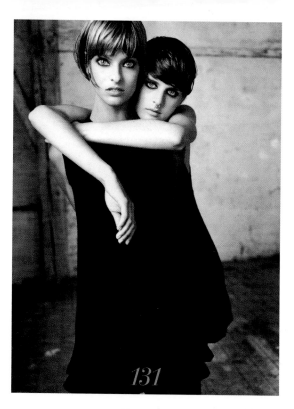

131

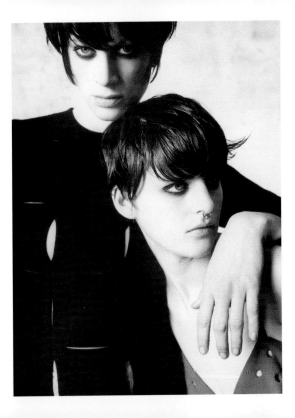

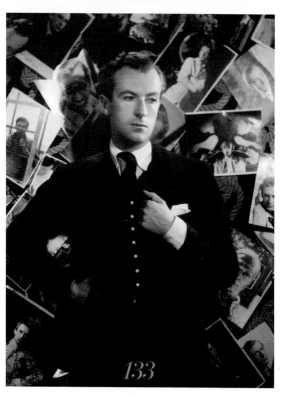

133

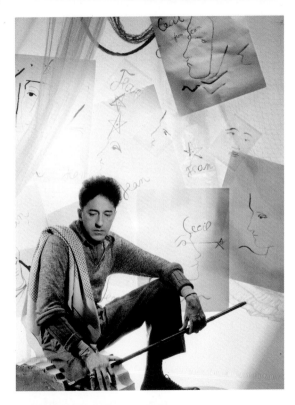

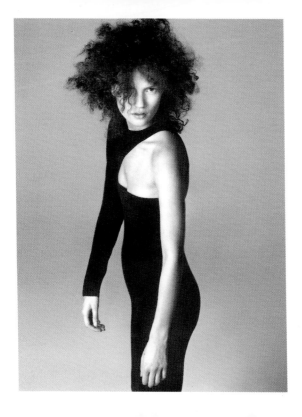

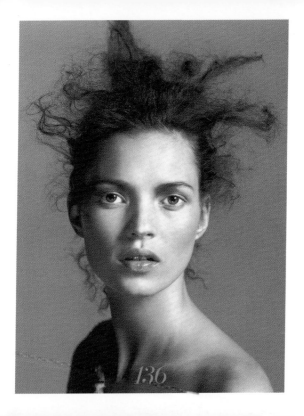

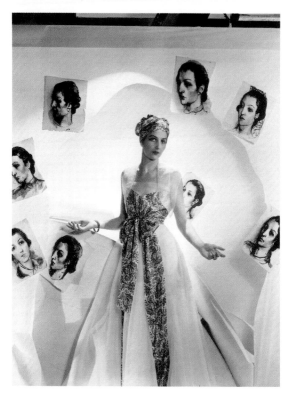

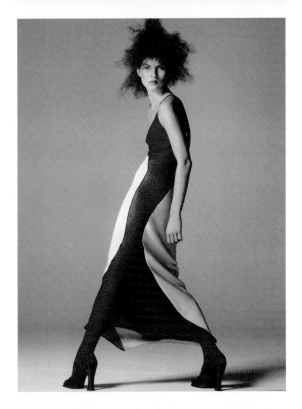

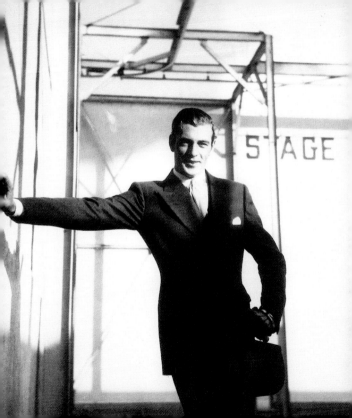

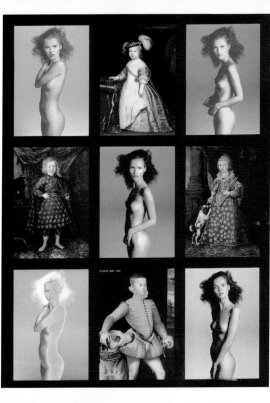

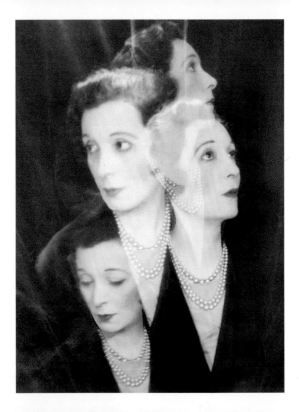

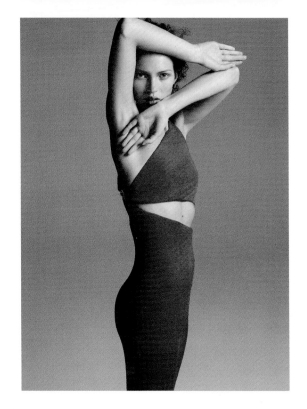

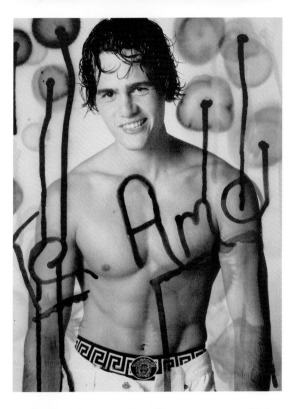

THE
ROYALTY
OF
ART

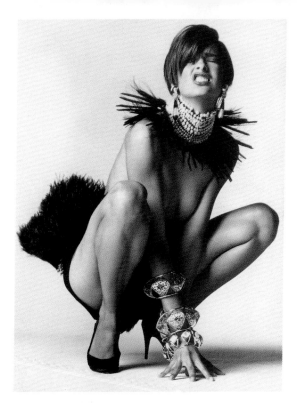

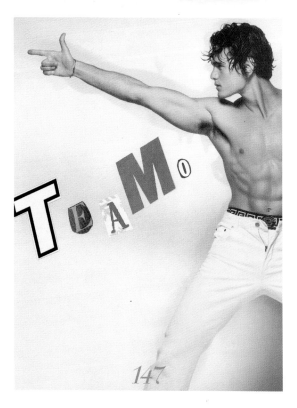

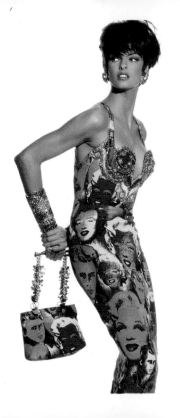

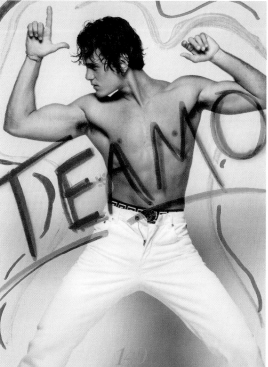

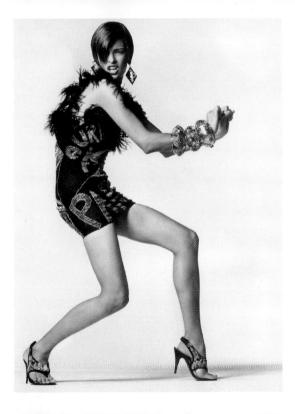

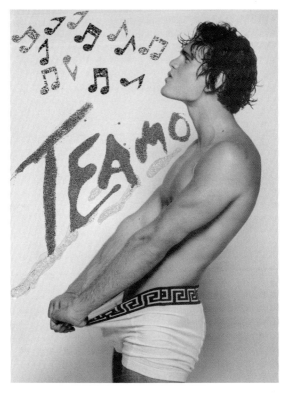

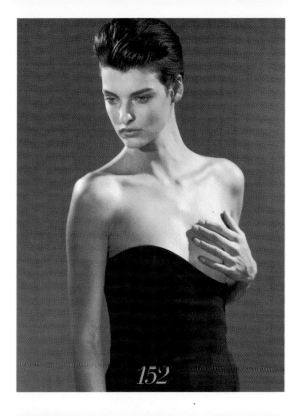

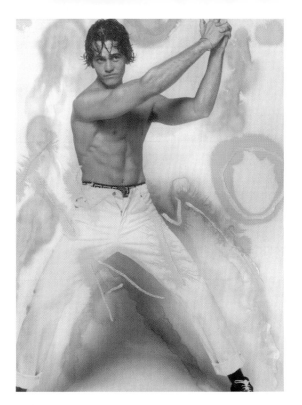

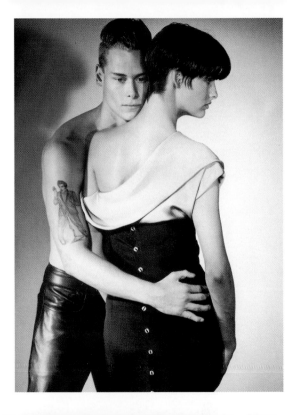

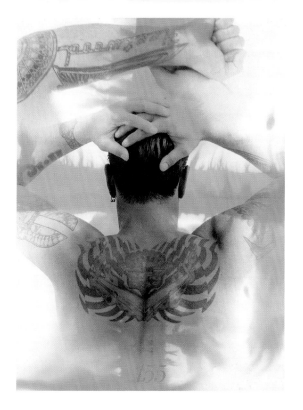

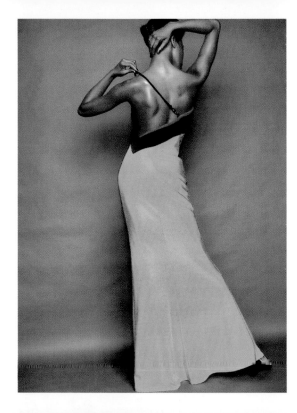

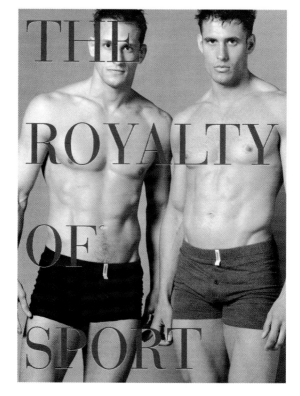

THE ROYALTY OF SPORT

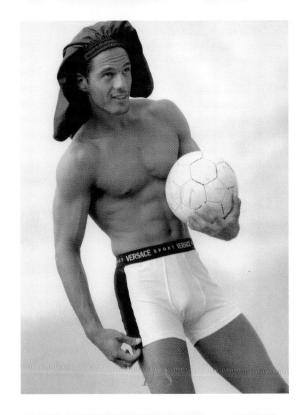

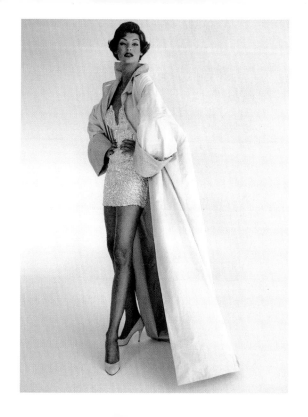

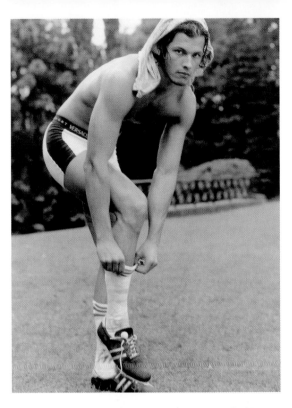

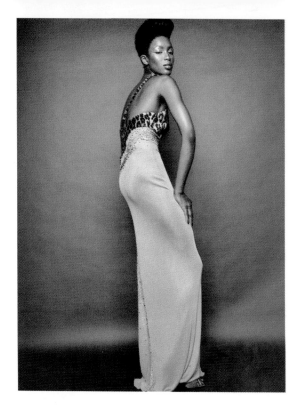

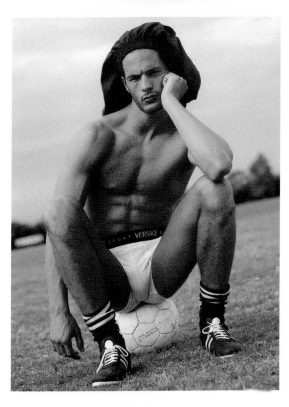

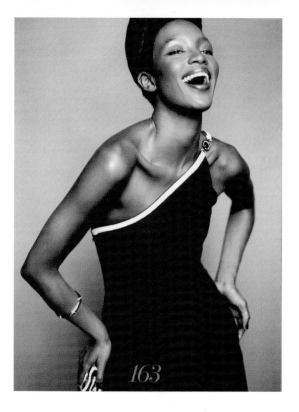

163

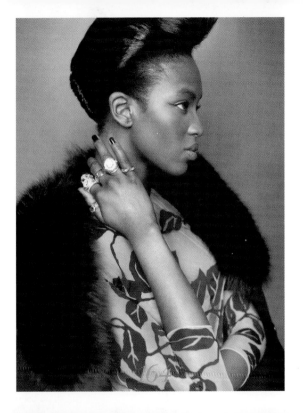

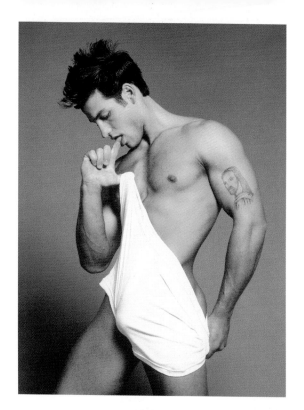

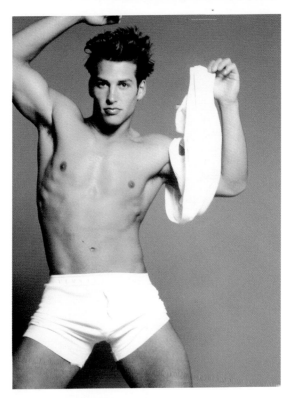

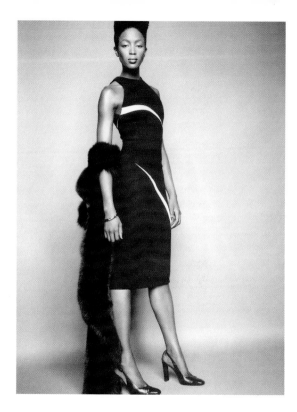

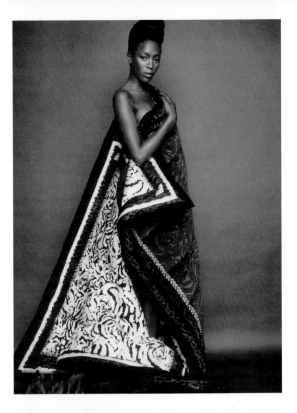

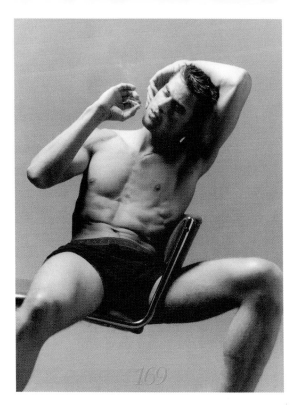

169

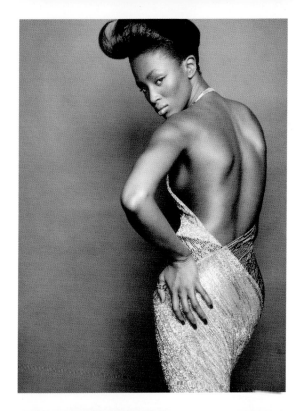

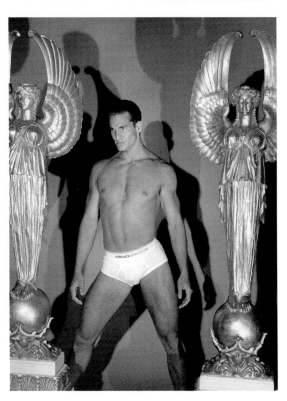

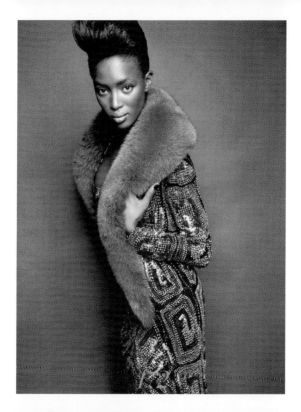

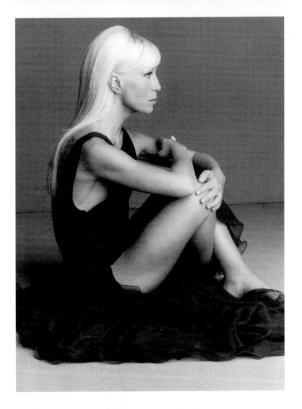

175

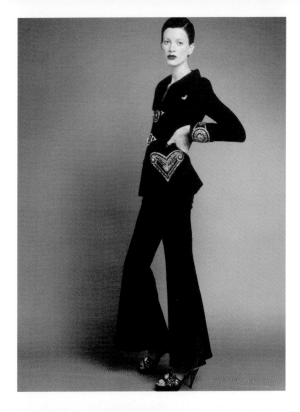

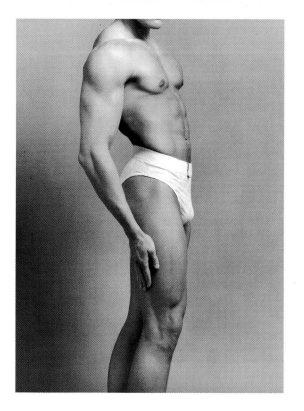

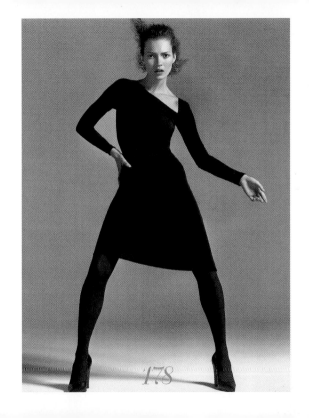

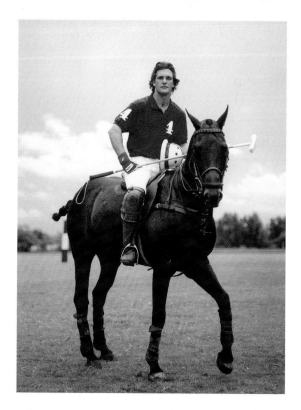

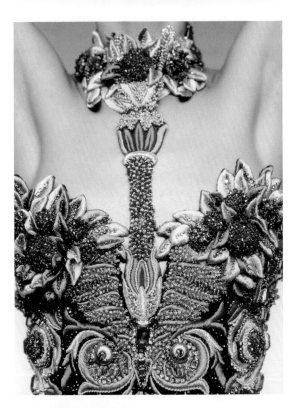

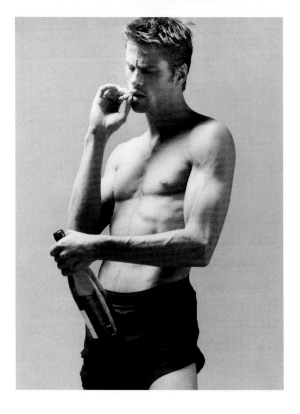

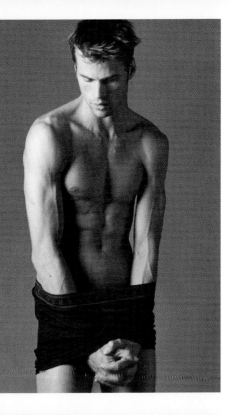

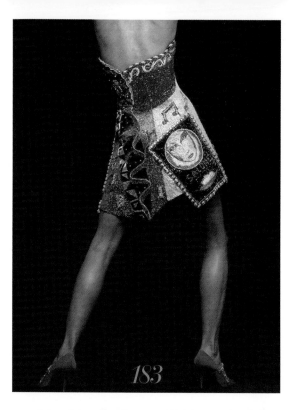

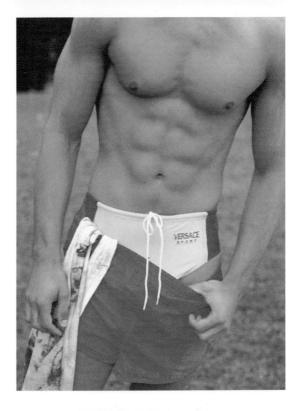

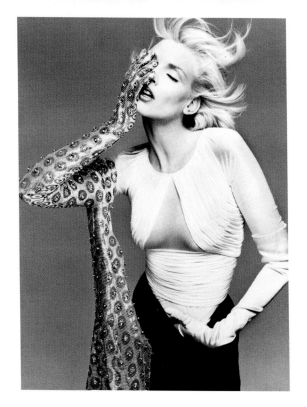

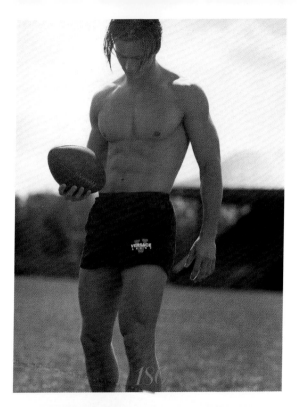

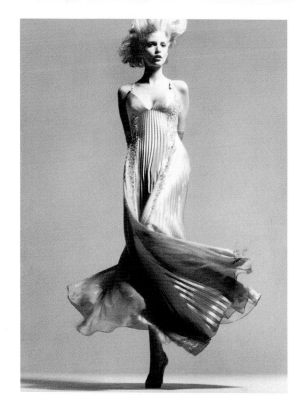

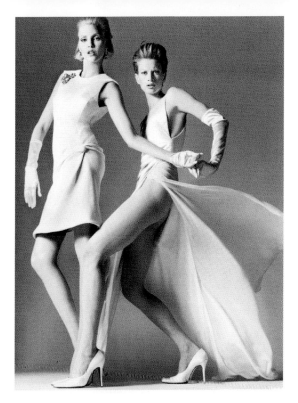

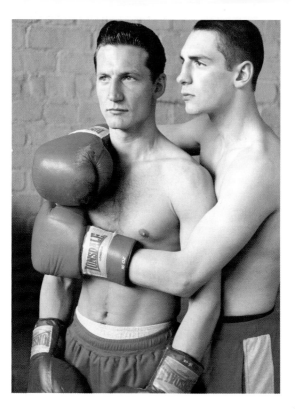

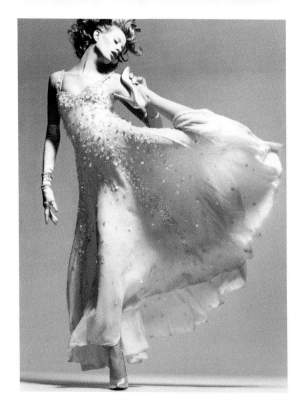

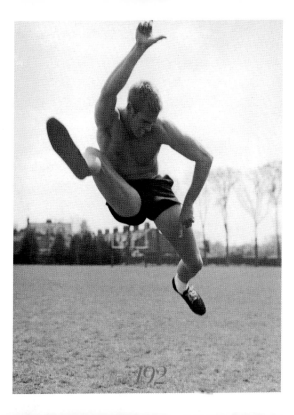

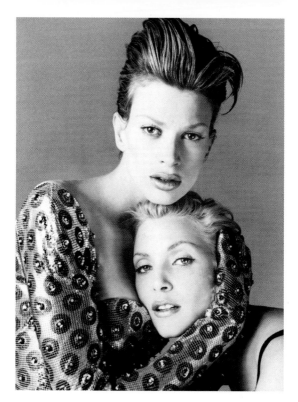

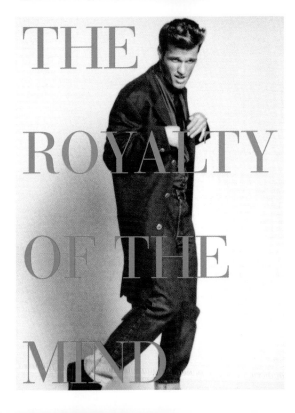

THE
ROYALTY
OF THE
MIND

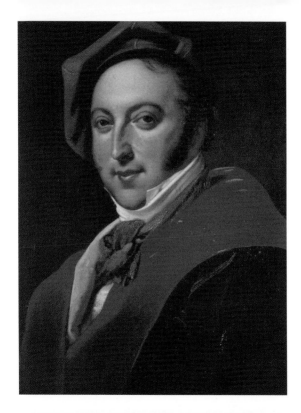

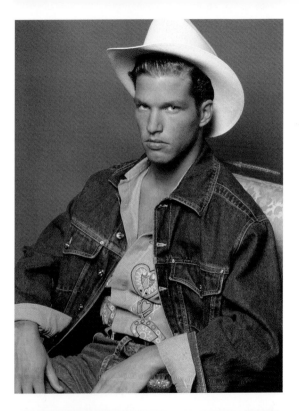

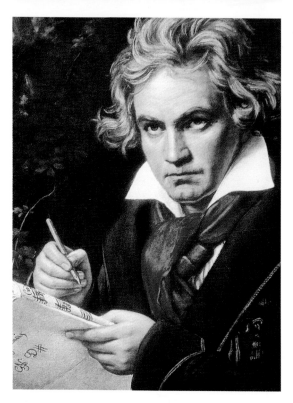

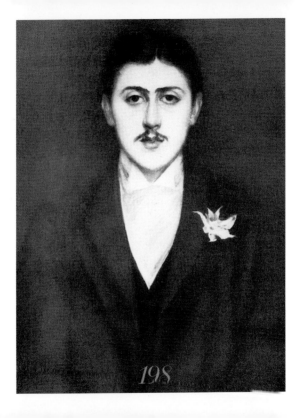

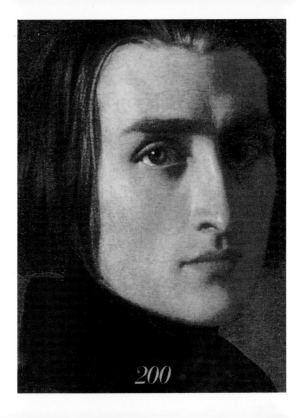

200

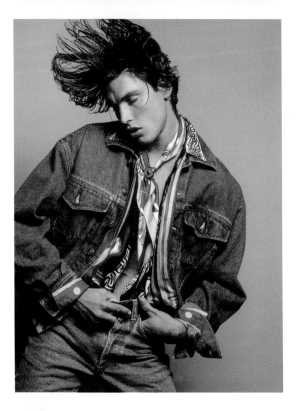

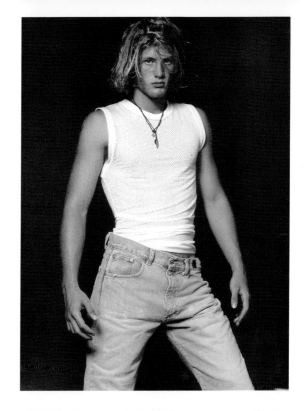

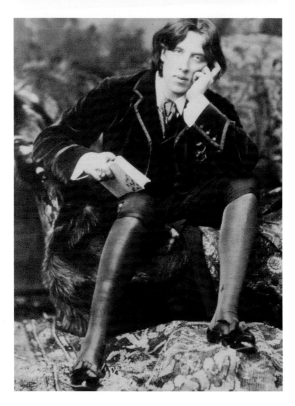

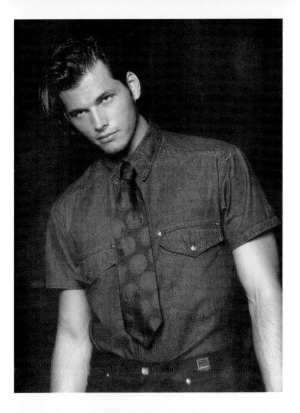

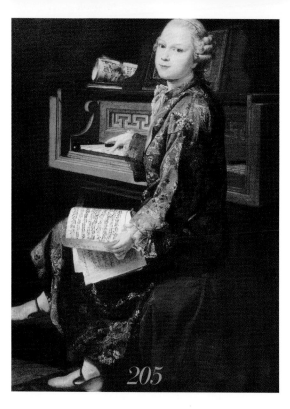

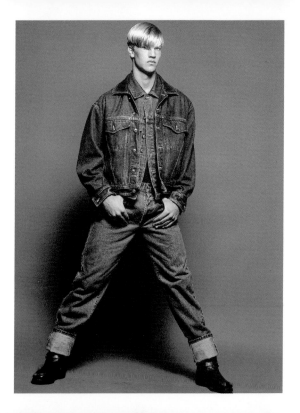

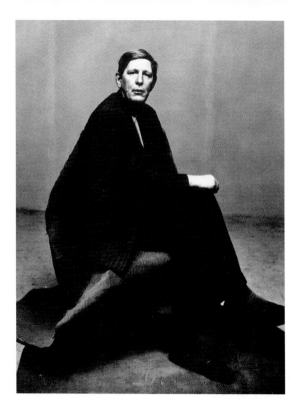

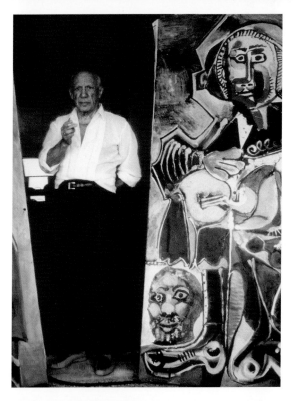

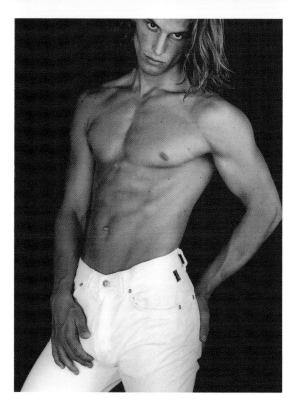

THE

ROYALTY

OF

FASHION

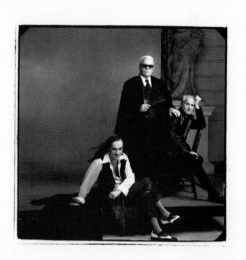

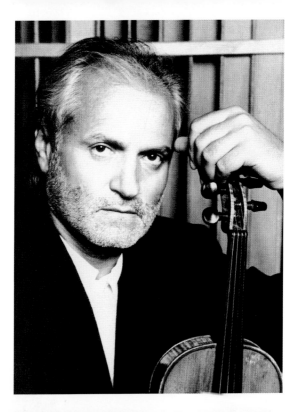

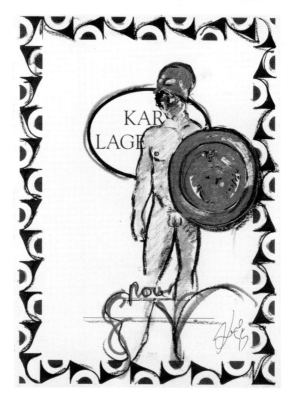

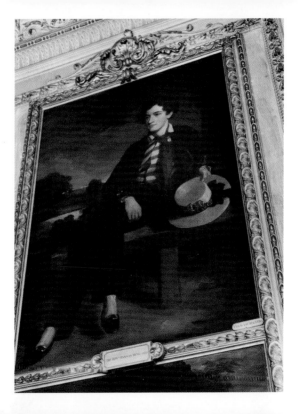

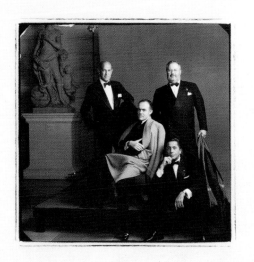

215

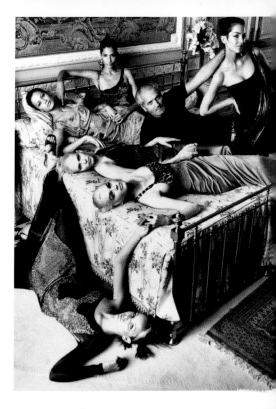

Dear Helmut.

Who, in your opinion, is a real rock 'n' roll photographer?

Who is the real royalty among the photographers of the past and of the present?

Who, according to you, might join the royalty of photography in the future?

Since, in my opinion, you are a royal, can you tell me what makes a person outstanding, different, and a royal in his own field?

Dear Gianni.
Re your questions:
Thank you for electing me
a Royal. I couldn't agree
more with you.
As a matter of fact the
answer to your first three
questions is:
Me, Me, Me!!!
As for No. 4. Dear Gianni.
I don't rightly know.

Love as ever Helm

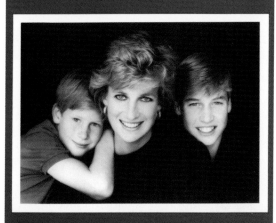

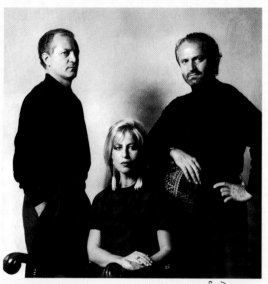

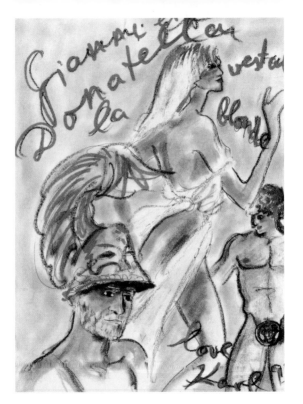

Azzedine Alaïa, Walter Albini, Giorgio Armani,
Cristóbal Balenciaga, Pierre Balmain, Geoffrey Beene,
Biki, Bill Blass, Pierre Balmain, Coco Chanel,
André Courrèges, Christian Dior, Oscar de la
Renta, Jacques Fath, Fendi, John Galliano, Jean
Federico Forquet, Givenchy, Princess
Irene Galitzine, John Galliano, Jean
Paul Gaultier, Roberto Capucci, Norman Hartnell, Givenchy
Hermès, Gucci, Halston, Madame Grès,
Katharine Hamnett, Norma Kamali, Donna Karan, Kenzo, Anne
Calvin Klein, Krizia, Christian Lacroix,
Karl Lagerfeld, Helmut Lang, Jeanne Lanvin, Guy
Norma Kamali, Donna Karan, Mainbocher, Anne Maxwell,
Calvin Klein, Krizia, Christian Lacroix,
Issey Miyake, Krizia, Christian Lacroix,
Karl Lagerfeld, Helmut Lang, Jeanne Lanvin, Guy
Laroche, Ralph Lauren, Mary Maxwell,
Issey Miyake, Emilio Pucci, Mary
Miyake, Prada, Edward Molyneux, Mary
Miyake, Paco Rabanne, Zandra Rhodes, Nina Ricci,
Yves Saint Laurent, Elsa Schiaparelli
Todd Oldham, Mila Schön, Nina Sui, Jil Sander, Richard Tyler, Pauline Trigère,
Quant, Paco Rabanne, Valentino, Madeleine Vionnet,
Marcel Rochas, Zoran
Quentin, Yves Saint Laurent, Zandra Rhodes, Nina Ricci,
Marcel Rochas, Yves Saint Laurent, Schiaparelli, Nina Ricci,
Laurent, Jil Sander, Richard Tyler, Pauline Trigère,
Mila Schön, Valentino, Jil Sander, Richard Tyler, Pauline Trigère,
Emanuel Ungaro, Valentino, Madeleine Vionnet,
Vivienne Westwood, Charles Worth, Zoran

"Gianni Versace is his afraid to change Dr words in his vocabula ttle others wallow

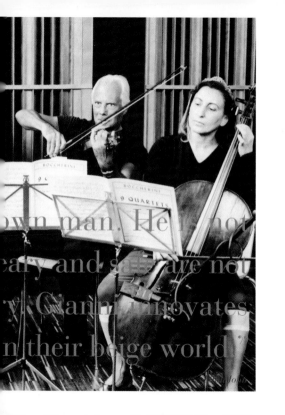

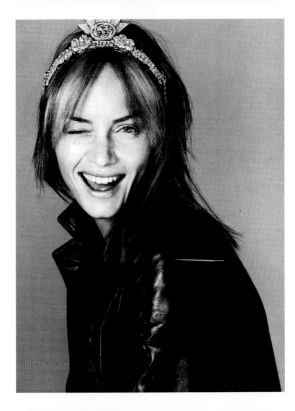

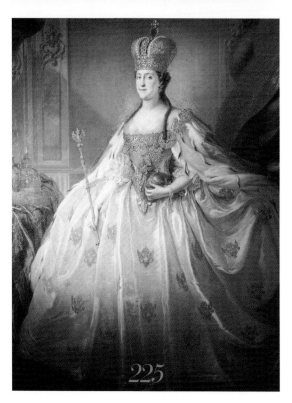

225

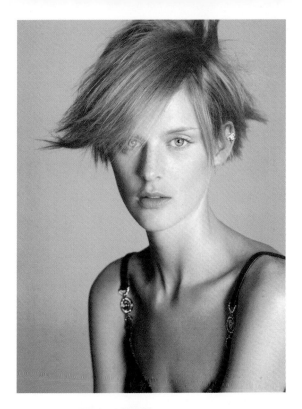

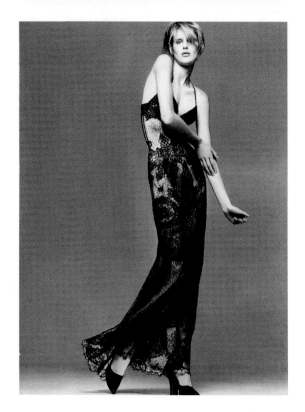

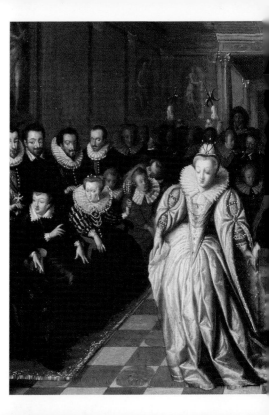

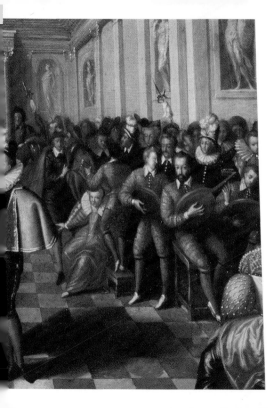

"Versace fashion is sexy fun and always beautiful."

Elton John

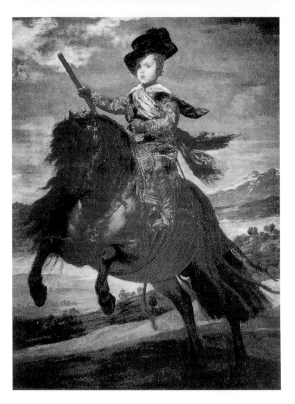

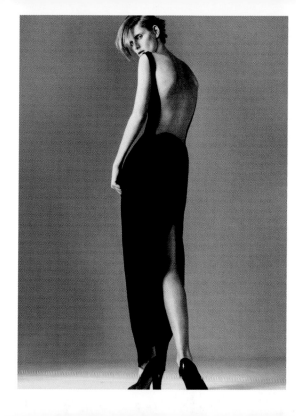

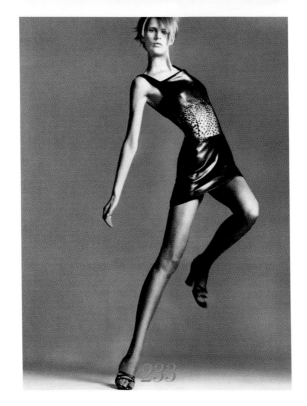

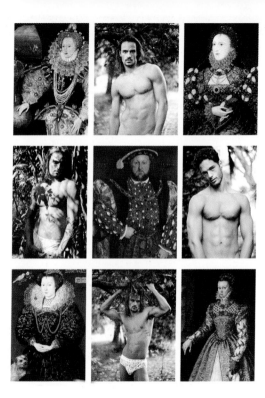

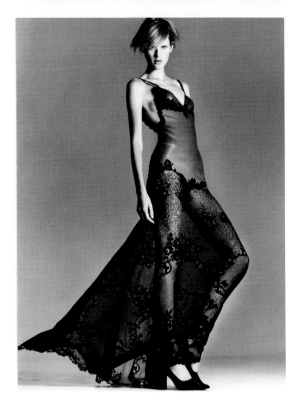

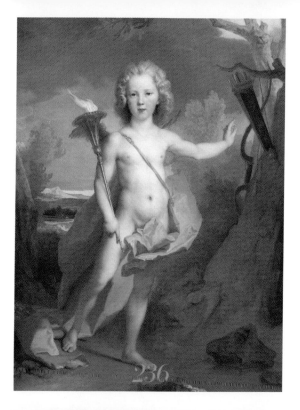

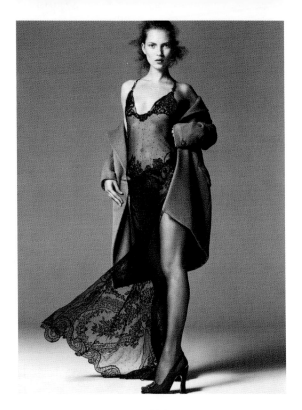

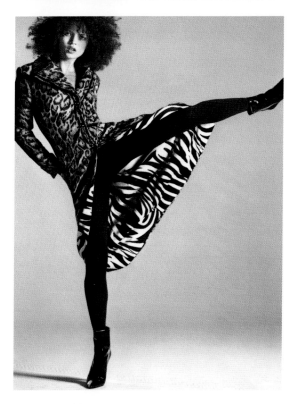

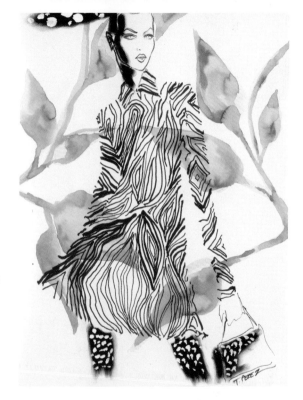

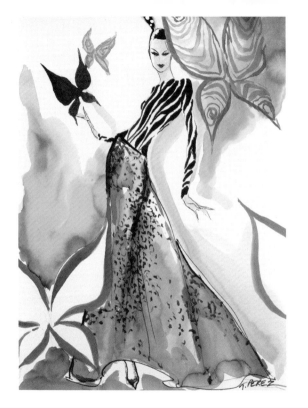

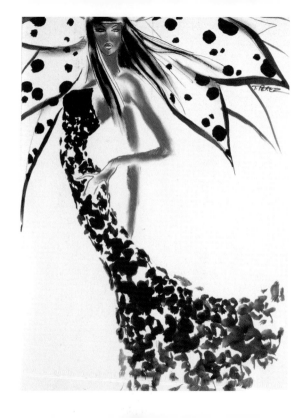

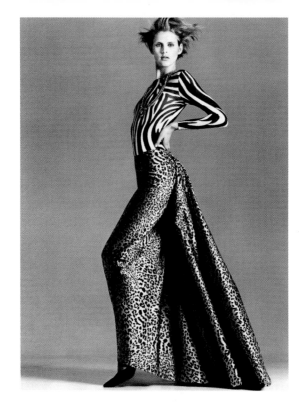

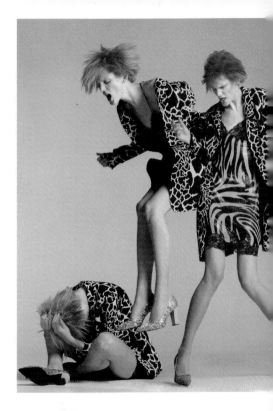

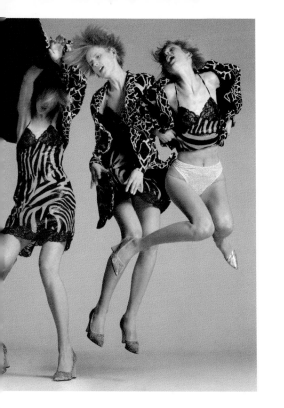

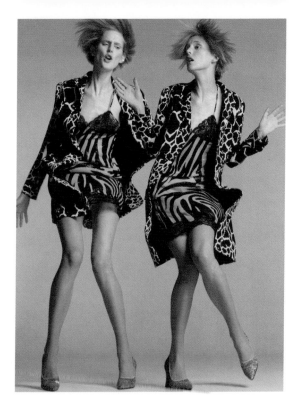

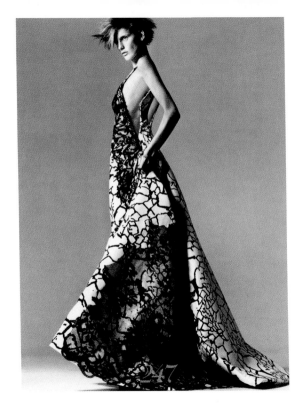

247

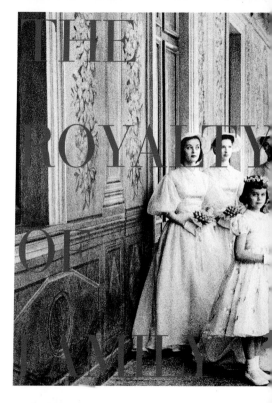

THE
ROYALTY
OF
FAMILY

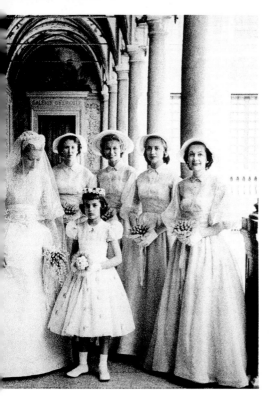

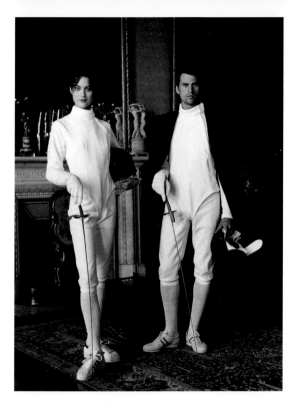

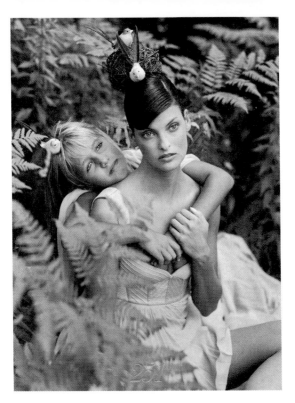

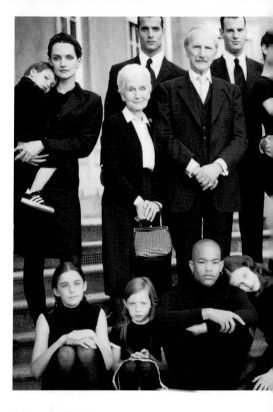

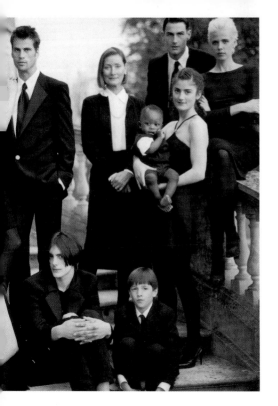

Funeral blues

Stop all the clocks, cut off the telephone,
Prevent the dog from barking with a
 juicy bone,
Silence the pianos and with muffled drum
Bring out the coffin, let the mourners come.

Let aeroplanes circle moaning overhead
Scribbling on the sky the message
 He Is Dead.
Put crepe bows round the white necks of the
 public doves,
Let the traffic policeman wear black gloves.

He was my North, my South, my East and
West, my working week and my
 Sunday rest,
My noon, my midnight, my talk, my song;
I thought that love would last forever:
 I was wrong. The stars are not wanted now:
 Put out every one,
Pack up the moon and dismantle the sun;
 Pour away the ocean and sweep up the wood.
For nothing now can ever come to any good.

<div align="right">W. H. Auden</div>

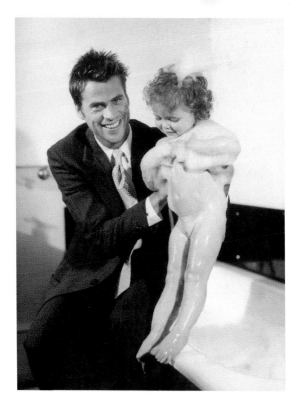

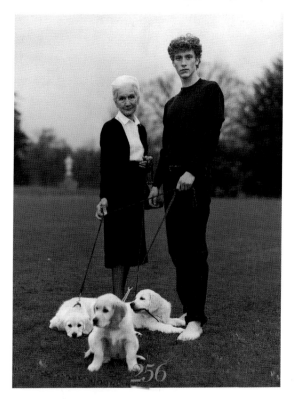

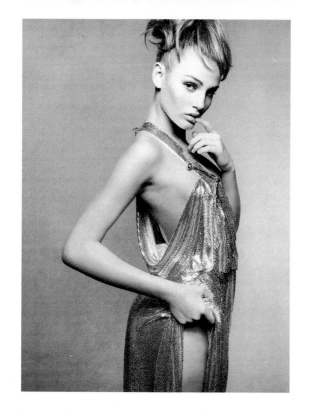

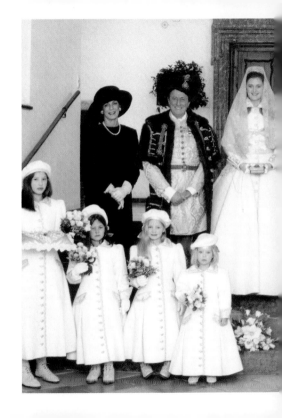

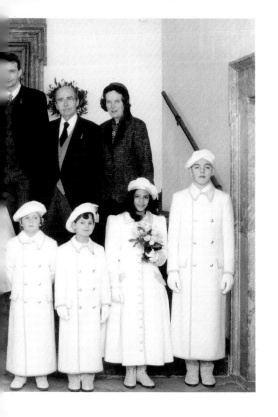

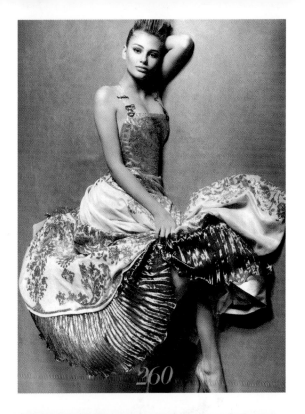

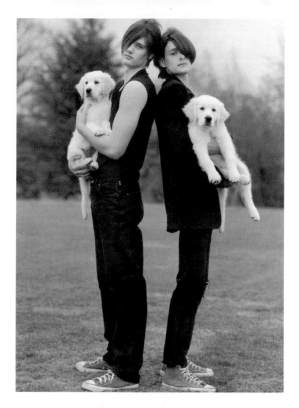

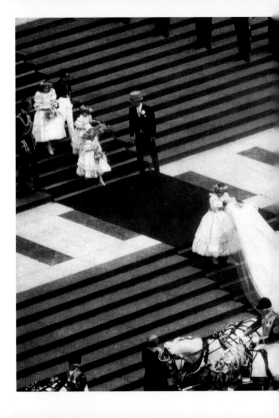

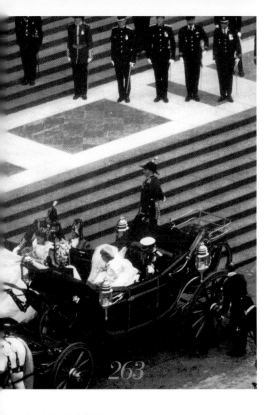

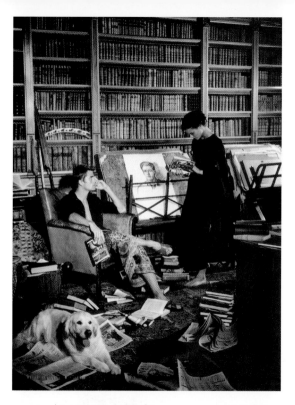

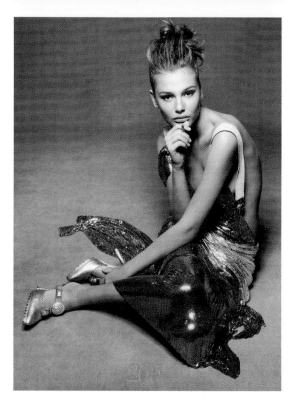

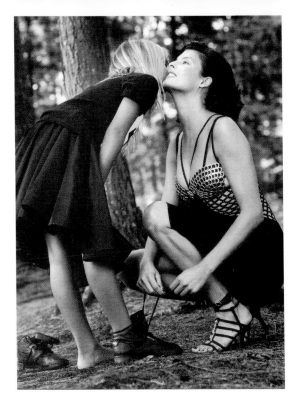

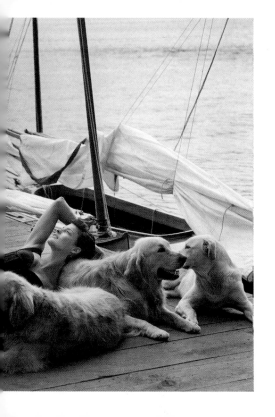

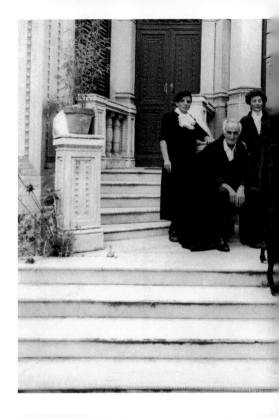

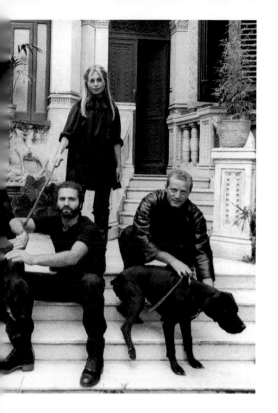

272.

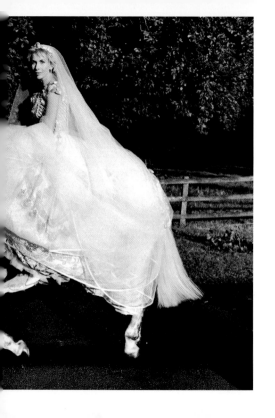

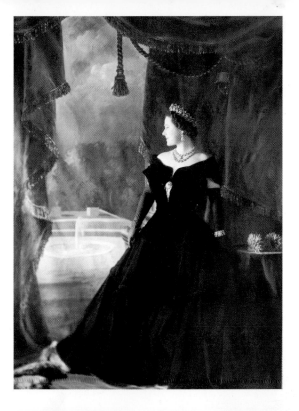

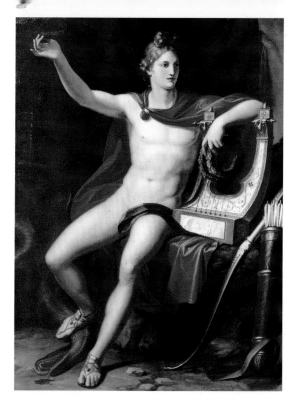

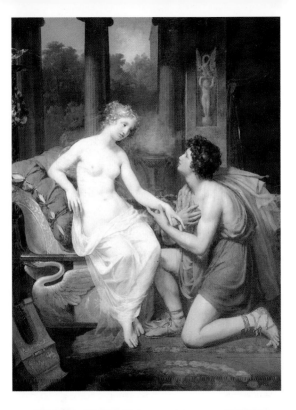

PHOTOGRAPHS

Listed by page number.

2 Underwear Fall/
 Winter 96/97 (Bruce
 Weber)

3 Women's collection
 Spring/Summer 89
 (Bruce Weber)

5 Elton John and
 Nadja Auermann,
 Spring/Summer 95
 (Richard Avedon)

7 Elton John and
 Kirsten McMenamy,
 Spring/Summer 95
 (Richard Avedon)

8 Elton John and
 Kirsten McMenamy,
 Spring/Summer 95
 (Richard Avedon)

10 Elvis Presley, Spring/
 Summer 89 (Bruce
 Weber)

11 Lisa Marie Presley,
 Versace Atelier Fall/
 Winter 96/97 (Mario
 Testino)

12 Underwear Spring/
 Summer 89 (Bruce
 Weber)

13 Lisa Marie Presley,
 Versace Atelier,
 American *Vogue*,

April 1996 (Steven
 Meisel)

14 Lisa Marie Presley,
 Versace Atelier
 Fall/Winter 96/97
 (Mario Testino)

15 Men's collection
 Spring/Summer 89
 (Bruce Weber)

16 Lisa Marie Presley,
 Versace Atelier
 Fall/Winter 96/97
 (Mario Testino)

17 Lisa Marie Presley,
 Versace Atelier Fall/
 Winter 96/97 (Mario
 Testino)

18 Tina Turner, Ameri-
 can *Elle*, August 96
 (Gilles Bensimon)

19 Tina Turner,
 Women's collection
 Spring/Summer 96
 (Manuelina
 Brambatti)

20 Sting, Men's collec-
 tion Spring/Summer
 96 (Thierry Perez)

21 Prince, Men's collec-
 tion Spring/Summer
 91 (Thierry Perez)

22 Cher, Women's col-
 lection Spring/
 Summer 89 (Thierry
 Perez)

23 Madonna, Women's
 collection Fall/
 Winter 91/92
 (Thierry Perez)

24 Grace Jones,
 Women's collection
 Fall/Winter 92/93
 (Thierry Perez)

25 Tina Turner,
 Women's collection
 Spring/Summer 92
 (Thierry Perez)

26–27 Elton John,
 Sheryl Crow, Sharon
 Stone (Bruno
 Gianesi, Manuelina
 Brambatti)

28 "Un des cavaliers
 du Carrousel des
 Galants Maures,"
 17th century (Jean
 Bérain)

29 Madonna, Versace
 Atelier Fall/Winter
 95/96 (Mario
 Testino)

30 Madonna, Versace

Atelier Fall/Winter 95/96 (Mario Testino)

31 B. Gagneraux, Rome 1789

32 Louis 14th, 18th century

33 Madonna, Versace Atelier Fall/Winter 95/96 (Mario Testino)

34 Portrait of François I on horseback (François Clouet)

35 Madonna, Women's collection Spring/Summer 95 (Steven Meisel)

36 Madonna, Women's collection Spring/Summer 95 (Steven Meisel)

37 Le Roi Soleil

38 Lady Waugh, about 1615 (William Larkin)

39 Madonna, Versace Atelier Fall/Winter 95/96 (Mario Testino)

40 Madonna, Versace Atelier Fall/Winter 95/96 (Mario Testino)

41 Portrait, 18th century

42 Home Signature Spring/Summer 96 (Bruce Weber)

43 Madonna, Versace Atelier Fall/Winter 95/96 (Mario Testino)

44 Eric Clapton, 1990 concert (Fabrizio Manni)

45 Lady St. John, about 1615–19 (William Larkin)

46 Anne of Denmark 1617 (Paul van Somer)

47 Jon Bon Jovi, Men's collection Spring/Summer 96 (Bruce Weber)

48 Jon Bon Jovi, Men's collection Spring/Summer 96 (Bruce Weber)

49 Amber Valletta and her brothers, Women's collection Spring/Summer 96 (Richard Avedon)

50 HRM Queen Elizabeth, about 1599 (School of Nicholas Hilliard)

51 Jon Bon Jovi, Men's collection Spring/

Summer 96 (Bruce Weber)

52 Luciano Pavarotti and Gianni Versace, 1996 (Paolo Castaldi)

53 Mina dressed by Gianni Versace, 1996 (Mauro Balletti)

54 Versace Atelier, Italian Vogue, September 1996 (Helmut Newton)

55 Mina, 1996 (Mauro Balletti)

56 Mrs. Richard Rogers, later Lady Smith (William Larkin)

57 Take That, Men's collection Spring/Summer 94 (Tiziano Magni)

58 Take That, Men's collection Spring/Summer 94 (Tiziano Magni)

59 Mina dressed by Gianni Versace,1996 (Mauro Balletti)

60 Portrait of Dorothy Cary, later Viscountess Rochford (William Larkin)

61 Take That, Men's

collection Spring/
Summer 94 (Tiziano
Magni)

62 Linda Evangelista,
Versace Atelier
Spring/Summer 95
(Bruce Weber)

63 Take That, Men's
collection Spring/
Summer 94 (Tiziano
Magni)

64 Take That, Men's
collection Spring/
Summer 94 (Tiziano
Magni)

65 Kate Moss, Women's
collection Fall/
Winter 96/97
(Richard Avedon)

67 k.d. lang and Dona-
tella Versace, *Inter-
view* March 1994
(Sante D'Orazio)

68 Prince, Men's collec-
tion Fall/
Winter 95/96
(Richard Avedon)

69 Kirsten McMenamy,
Women's collection
Fall/Winter 95/96
(Richard Avedon)

70 Prince, Men's collec-
tion Fall/
Winter 95/96
(Richard Avedon)

71 Kirsten McMenamy,
Women's collection
Fall/Winter 95/96
(Richard Avedon)

72 Prince, Men's collec-
tion Fall/Winter
95/96 (Richard
Avedon)

73 Amber Valletta, Trish
Goff and Shalom,
Women's collection
Fall/Winter 95/96
(Richard Avedon)

74 Amber Valletta,
Women's collection
Spring/Summer
1996 (Richard
Avedon)

75 Prince, Men's collec-
tion Fall/
Winter 95/96
(Richard Avedon)

76 Prince, Men's collec-
tion Fall/
Winter 95/96
(Richard Avedon)

77 Kirsten McMenamy,
Women's collection
Fall/Winter 95/96
(Richard Avedon)

78 Stella Tennant,
Women's collection
Fall/Winter 95/96
(Bruce Weber)

79 Stella Tennant,

Women's collection
Fall/Winter 95/96
(Bruce Weber)

80 Portrait of Louis II of
Bavaria, 19th century

81 Claudia Schiffer,
Nadja Auermann,
Women's collection
Spring/Summer 95
(Richard Avedon)

83 HRM Queen Eliza-
beth I, Buckingham
Palace 1939 (Cecil
Beaton)

84 Marilyn Monroe,
New York 1957
(Richard Avedon)

85 HRM Queen Eliza-
beth II, 1953 (Cecil
Beaton)

86 Kate Moss, Women's
collection Fall/
Winter 96/97
(Richard Avedon)

87 Cecil Beaton, 1936
(Paul Tanqueray)

88 Portrait of Louis II of
Bavaria, 19th century

89 Versace Atelier
Spring/Summer 91
(Tyen)

90 Men's collection
Fall/Winter 94/95
(Bruce Weber)

91 HRM Queen

Elizabeth II, 1945
(Cecil Beaton)

92 The Hon. Mrs. Regi-
nald Fellowes, Bei-
stegui Ball, Venice
1951 (Cecil Beaton)

93 Naomi Campbell,
Women's collection
Fall/Winter 90/91
(Herb Ritts)

94 Kate Moss, Women's
collection Fall/
Winter 96/97
(Richard Avedon)

95 Linda Evangelista,
Versace Atelier
Spring/Summer 95
(Bruce Weber)

96 Kate Moss, Women's
collection Fall/
Winter 96/97
(Richard Avedon)

97 Gwili Andre, 1930
(Cecil Beaton)

98 Nadja Auermann,
Versace Atelier
Spring/Summer 95
(Richard Avedon)

99 Edith Sitwell, 1927
(Cecil Beaton)

100 Men's collection
Spring/Summer 95
(Bruce Weber)

101 Cecil Beaton, 1937
(Paul Tanqueray)

102 Self-portrait, 1971
(Robert Mapple-
thorpe)

103 Edith Sitwell, 1927
(Cecil Beaton)

104 Donatella Versace,
Carnival 1966

105 Allegra Versace
Beck, 1994 (Bruce
Weber)

106 Boy Le Bas, Cam-
bridge 1924 (Cecil
Beaton)

107 Istante Fall/Winter
96/97 (Bruce Weber)

109 Empire portrait,
about 1800–1820

110 Napoleon Bona-
parte, First Consul
1804 (Jean-Auguste-
Dominique Ingres)

112–13 Charles James
dresses for American
Vogue, 1948 (Cecil
Beaton)

114 Linda Evangelista,
Versace Atelier
Spring/Summer 95
(Bruce Weber)

115 HRM Queen
Elizabeth II, 1955
(Cecil Beaton)

116 "Dessin pour le
costume de Pluton"
(Jean Bérain),

Versace Atelier
Fall/Winter 90/91
(Guy Marineau)

117 Home Signature
Fall/Winter 96/67
(Bruce Weber)

118 The Duke and
Duchess of Windsor
on their wedding
day, at the Château
de Candé, 1937
(Cecil Beaton)

119 Home Signature
Spring/Summer 96
(Richard Avedon)

120 Fashion 1938
(Cecil Beaton)

121 Linda Evangelista,
Kirsten McMenamy
and Ingrid, Versace
Atelier Fall/Winter
93/94 (Steven
Meisel)

122 Untitled, 1930
(Cecil Beaton)

123 Linda Evangelista,
Kirsten McMenamy
and Stella Tennant,
Versace Atelier Fall/
Winter 93/94
(Steven Meisel)

124 Irene in ballgown
before a canvas by
Jackson Pollock at

Betty Parsons Gallery, 1951 (Cecil Beaton)

125 Kirsten McMenamy and Ingrid, Versace Atelier Fall/Winter 93/94 (Steven Meisel)

126 Kirsten McMenamy, Versace Atelier Fall/Winter 93/94 (Steven Meisel)

127 HRM Queen Victoria, 1899

128–29 Versace Jeans Couture Fall/Winter 96/97 (Bruce Weber)

130 Linda Evangelista and Kirsten McMenamy, Versace Atelier Fall/Winter 93/94 (Steven Meisel)

131 Linda Evangelista and Stella Tennant, Versace Atelier Fall/Winter 93/94 (Steven Meisel)

132 Kirsten McMenamy and Stella Tennant, Versace Atelier Fall/Winter 93/94 (Steven Meisel)

133 Cecil Beaton, about

1930 (Paul Tanqueray)

134 Jean Cocteau, about 1935–37 (Cecil Beaton)

135 Kate Moss, Women's collection Fall/Winter 96/97 (Richard Avedon)

136 Kate Moss, Women's collection Fall/Winter 96/97 (Richard Avedon)

137 Composite, about 1950 (Cecil Beaton)

138 Kate Moss, Women's collection Fall/Winter 96/97 (Richard Avedon)

139 Gary Cooper, 1931 (Cecil Beaton)

140 Kate Moss, Women's collection Fall/Winter 96/97 (Richard Avedon)

141 Versace Atelier Spring/Summer 94 (Bruce Weber)

142 Untitled, 1930 (Cecil Beaton)

143 Kate Moss, Women's collection Fall/Winter 96/97 (Richard Avedon)

144 Versace Jeans

Couture Spring/ Summer 96 (Bruce Weber)

145 Linda Evangelista, Versace Atelier Spring/Summer 95 (Bruce Weber)

146 Versace Atelier, Italian *Vogue*, March 1990 (Steven Meisel)

147 Versace Jeans Couture Spring/ Summer 96 (Bruce Weber)

148 Linda Evangelista, Women's collection Spring/Summer 92 (Irving Penn)

149 Versace Jeans Couture Spring/ Summer 96 (Bruce Weber)

150 Versace Atelier, Italian *Vogue*, March 1990 (Steven Meisel)

151 Versace Jeans Couture Spring/Summer 96 (Bruce Weber)

152 Linda Evangelista, Women's collection Spring/Summer 89 (Bruce Weber)

153 Versace Jeans

Couture Spring/
Summer 96 (Bruce
Weber)

154 Linda Evangelista,
Women's collection
Spring/Summer 89
(Bruce Weber)

155 Men's collection
Spring/Summer 94
(Bruce Weber)

156 Naomi Campbell,
Versace Atelier Fall/
Winter 96/97 (Mario
Testino)

157 Versace Sport Fall/
Winter 96/97 (Bruce
Weber)

158 Versace Sport
Spring/Summer 96
(Bruce Weber)

159 Linda Evangelista,
Versace Atelier,
Vogue UK, October
1991(Patrick
Demarchelier)

160 Versace Sport
Spring/Summer 96
(Bruce Weber)

161 Naomi Campbell,
Versace Atelier
Fall/Winter 96/97
(Mario Testino)

162 Versace Sport
Spring/Summer 96
(Bruce Weber)

163 Naomi Campbell,
Versace Atelier
Fall/Winter 96/97
(Mario Testino)

164 Naomi Campbell,
Versace Atelier
Fall/Winter 96/97
(Mario Testino)

165 Underwear Fall/
Winter 96/97 (Bruce
Weber)

166 Underwear Fall/
Winter 96/97 (Bruce
Weber)

167 Naomi Campbell,
Versace Atelier
Fall/Winter 96/97
(Mario Testino)

168 Naomi Campbell,
Home Signature
Fall/Winter 96/97
(Mario Testino)

169 Underwear Fall/
Winter 96/97 (Bruce
Weber)

170 Naomi Campbell,
Versace Atelier Fall/
Winter 96/97 (Mario
Testino)

171 Underwear Fall/
Winter 96/97 (Bruce
Weber)

172 Naomi Campbell,
Versace Atelier Fall/

Winter 96/97 (Mario
Testino)

173 Home Signature
Spring/Summer 96
(Bruce Weber)

174 Donatella Versace,
Atelier Spring/
Summer 93 (Steven
Meisel)

175 Shoes Spring/
Summer 96 (Bruce
Weber)

176 Kirsten McMenamy,
Versace Atelier,
American *Vogue*,
October 1992
(Steven Meisel)

177 Underwear Fall/
Winter 96/97 (Bruce
Weber)

178 Kate Moss,
Women's collection
Fall/Winter 96/97
(Richard Avedon)

179 Versace Sport
Spring/Summer 96
(Bruce Weber)

180 Women's collection
Fall/Winter 91/92
(Herb Ritts)

181 Men's collection
Fall/Winter 96/97
(Bruce Weber)

182 Underwear Fall/

Winter 96/97 (Bruce Weber)

183 Women's collection Fall/Winter 91/92 (Herb Ritts)

184 Versace Sport Spring/Summer 96 (Bruce Weber)

185 Nadja Auermann, Versace Atelier Spring/Summer 95 (Richard Avedon)

186 Versace Sport Spring/Summer 96 (Bruce Weber)

187 Nadja Auermann, Versace Atelier Spring/Summer 95 (Richard Avedon)

188 Nadja Auermann and Kirsten McMenamy, Versace Atelier Spring/Summer 95 (Richard Avedon)

189 Versace Sport Fall/Winter 96/97 (Bruce Weber)

190 Versace Sport Spring/Summer 96 (Bruce Weber)

191 Kirsten McMenamy, Versace Atelier Spring/Summer 95 (Richard Avedon)

192 Versace Sport Fall/Winter 96/97 (Bruce Weber)

193 Nadja Auermann and Kirsten McMenamy, Versace Atelier Spring/Summer 95 (Richard Avedon)

194 Versace Jeans Couture Fall/Winter 95/96 (Bruce Weber)

195 Portrait of Gioachino Rossini (M. Mayer)

196 Versace Jeans Couture Spring/Summer 91 (Bruce Weber)

197 Beethoven composing *Missa Solemnis* (after Josef Stieler 1819)

198 Portrait of Marcel Proust 1892 (J. E. Blanche)

199 Versace Jeans Couture Spring/Summer 91 (Bruce Weber)

200 Portrait of Franz Liszt (Henry Lehmann)

201 Versace Jeans Couture Spring/

Summer 91 (Bruce Weber)

202 Versace Jeans Couture Spring/Summer 94 (Bruce Weber)

203 Portrait of Oscar Wilde, 1882

204 Versace Jeans Couture Spring/Summer 96 (Bruce Weber)

205 Portrait of Wolfgang Amadeus Mozart (J. Duplessis)

206 Versace Jeans Couture Spring/Summer 91 (Bruce Weber)

207 W. H. Auden, New York 1947 (Irving Penn)

208 Pablo Picasso in his studio (Alexander Libermann)

209 Versace Jeans Couture Spring/Summer 96 (Bruce Weber)

211 Karl Lagerfeld, John Galliano, Gianni Versace, American *Vogue*, March 1996 (Annie Leibovitz)

212 Portrait of Gianni Versace 1996 (Karl Lagerfeld)

213 Sketch by Karl
Lagerfeld

214 Men's collection
Fall/Winter 96/97
(Bruce Weber)

215 Gian Franco Ferré,
Oscar De La Renta,
Christian Lacroix,
Valentino, American
Vogue, March 1996
(Annie Leibovitz)

216–17 Versace Atelier,
Vanity Fair, July
1996 (Helmut
Newton)

218 HRH The Princess
of Wales and her
children

219 Gianni, Donatella,
and Santo Versace
1990 (Lord
Snowdon)

220 Sketch by Karl
Lagerfeld

222–23 Gianni Versace,
Valentino, Giorgio
Armani, Miuccia
Prada 1996 (Karl
Lagerfeld)

224 Amber Valletta,
Women's collection
Spring/Summer 96
(Richard Avedon)

225 Portrait of Cather-
ine II, Empress of
Russia

226 Stella Tennant,
Versace Atelier
Spring/Summer 96
(Richard Avedon)

227 Stella Tennant,
Versace Atelier
Spring/Summer 96
(Richard Avedon)

228–29 Mariage
d'Anne, Duc de
Joyeuse, et de
Marguerite de
Vaudémont, 1581

230 Amber Valletta,
Women's collection
Spring/Summer 96
(Richard Avedon)

231 Portrait of Prince
Baltasar Carlos,
about 1635
(Velázquez)

232 Stella Tennant,
Versace Atelier
Spring/Summer 96
(Richard Avedon)

233 Stella Tennant,
Versace Atelier
Spring/Summer 96
(Richard Avedon)

235 Stella Tennant,
Versace Atelier
Spring/Summer 96
(Richard Avedon)

236 Eros, 18th century
(French school)

237 Kate Moss,
Women's collection
Fall/Winter 96/97
(Richard Avedon)

238 Kate Moss,
Women's collection
Fall/Winter 96/97
(Richard Avedon)

239 Versace Atelier
Spring/Summer 96
(Thierry Perez)

240 Versace Atelier
Spring/Summer 96
(Thierry Perez)

241 Versace Atelier
Spring/Summer 96
(Thierry Perez)

242 Versace Atelier
Spring/Summer 96
(Thierry Perez)

243 Stella Tennant,
Versace Atelier
Spring/Summer 96
(Richard Avedon)

244–45 Stella Tennant,
Versace Atelier
Spring/Summer 96
(Richard Avedon)

246 Stella Tennant,
Versace Atelier
Spring/Summer 96
(Richard Avedon)

247 Stella Tennant,

Versace Atelier Spring/Summer 96 (Richard Avedon)

248–49 Grace Kelly, wedding day, April 1956 (Howell Conant)

250 Men's collection Fall/Winter 96/97 (Bruce Weber)

251 Linda Evangelista and Allegra Versace Beck, Versace Atelier Spring/Summer 95 (Bruce Weber)

252–53 Men's collection Fall/Winter 96/97 (Bruce Weber)

254 Men's collection Fall/Winter 96/97 (Bruce Weber)

255 Men's collection Fall/Winter 96/97 (Bruce Weber)

256 Men's collection Fall/Winter 96/97 (Bruce Weber)

257 Bridget Hall, Versace Atelier Spring/

Summer 94 (Steven Meisel)

258–59 Francesca Von Thyssen and Karl Von Habsburg, wedding day 1993 (Lichfield)

260 Bridget Hall, Versace Atelier Spring/Summer 94 (Steven Meisel)

261 Versace Jeans Couture Fall/Winter 96/97 (Bruce Weber)

262–63 The Prince and Princess of Wales after their wedding in St. Paul's Cathedral, 1981 (Freson)

264 Men's collection Fall/Winter 96/97 (Bruce Weber)

265 Bridget Hall, Versace Atelier Spring/Summer 94 (Steven Meisel)

266 Linda Evangelista,

Versace Atelier Spring/Summer 95 (Bruce Weber)

267 Linda Evangelista, Versace Atelier Spring/Summer 95 (Bruce Weber)

268–69 Linda Evangelista, Versace Atelier Spring/Summer 95 (Bruce Weber)

270–71 The Versace Family (Alfa Castaldi)

272–73 Sting and Trudie Styler, wedding day 1992 (Andrew Cooper)

274 The Queen Mother 1948 (Cecil Beaton)

275 Apollo, c. 1810 (Pietro Benvenuti)

276 Helen and Paris in Menelaus's palace (Charles Meynier 1768–1832)

ADDITIONAL PHOTOGRAPHIC CREDITS

The published photographic material comes from the archives of Gianni Versace SpA, with the exception of the photographs on the following pages:

13 Steven Meisel, *Vogue* USA, April 1996

18 Gilles Bensimon, *Elle* USA, August 1996

54 Helmut Newton. *Vogue* Italia, September 1996

67 Sante D'Orazio, *Vogue* USA, October 1992

146, 150 Steven Meisel, *Vogue* USA, March 1990

159 Patrick Demarchelier, *Vogue* UK, October 1991

176 Steven Meisel, *Vogue* USA, October 1992

211, 215 Annie Leibovitz, *Vogue* USA, March 1996

216–17 Helmut Newton, *Vanity Fair*, July 1996

Front and back cover: Bruce Weber

Art direction: Gianni Versace,
 Donatella Versace, Paul Beck
Graphic consultant: Mary Shanahan
Graphics: Enrico Genevois, Constance
 Astbury, Luisa Raponi
Picture research: Tatiana Mattioni,
 Fabrizia Curzio, Annamaria Stradella
Archive: Stefania Di Gilio, Annalisa
 Lucchini
Press office: Emanuela Schmeidler
General information: Patrizia Cucco

We would particularly like to thank
everyone who has contributed to
the Gianni Versace collections over
the years.

Leonardo Periodici
Editorial coordinator:
 Giuseppe Lamastra
Promotion and press:
 Gabriella Piomboni
Technical consultant: Gianni Gardel

*Library of Congress
Cataloging-in-Publication Data*
Rock and royalty / Gianni Versace. —
1st U.S. ed.
 p. cm.
 "A tiny folio."
 The ever-changing look of
Versace's couture as seen—and
modeled—by the kings, queens, and
jokers of rock & roll.
 ISBN 0-7892-0489-4
 1. Costume design—Pictorial
works. 2. Versace, Gianni.
3. Rock musicians—Portraits.
4. Celebrities—Portraits.
5. Fashion photography. 6. Portrait
photography. I. Versace, Gianni.
TT506.R63 1998
746.9'2—dc21 98-40474

Selected Tiny Folios™ from Abbeville Press

- Angels ♦ 0-7892-0403-7 ♦ $11.95

- Barbie ♦ 0-7892-0461-4 ♦ $11.95

- Goddesses ♦ 0-7892-0269-7 ♦ $11.95

- The Great Book of French Impressionism
 0-7892-0405-3 ♦ $11.95

- Hugs & Kisses ♦ 0-7892-0427-4 ♦ $11.95

- Men Without Ties ♦ 0-7892-0382-0 ♦ $11.95

- 100 Classic Cocktails ♦ 0-7892-0426-6 ♦ $11.95

- Treasures of Impressionism and Post-Impressionism:
 National Gallery of Art ♦ 1-55859-561-9 ♦ $11.95

- Treasures of the Louvre ♦ 0-7892-0406-1 ♦ $11.95

- Treasures of the Musée d'Orsay ♦ 0-7892-0408-8
 $11.95

- Women Artists: The National Museum of Women
 in the Arts ♦ 0-7892-0411-8 ♦ $11.95

- Wonder Woman: Five Decades of Great Covers
 0 7892 0012 0 ♦ $11.95